The European Emblem

Towards an
Index Emblematicus

Edited by

PETER M. DALY

Wilfrid Laurier University Press

Canadian Cataloguing in Publication Data

Main entry under title:

The European emblem

"Book arose directly out of a symposium held at
McGill University, Dec. 4-6, 1978."

Bibliography: p. *C*

ISBN 0-88920-090-4 ⊂

1. Emblems — Addresses, essays, lectures.
2. Emblem books — Addresses, essays, lectures.
I. Daly, Peter M., 1936-

PN6348.5.E97 704.9'46 C80-094290-6

6003711677

Copyright © 1980
WILFRID LAURIER UNIVERSITY PRESS
Waterloo, Ontario, Canada N2L 3C5
80 81 82 83 4 3 2 1

TABLE OF CONTENTS

LIST OF ILLUSTRATIONS

ACKNOWLEDGMENTS

It gives me pleasure to acknowledge the cooperation and encouragement of a number of individuals and institutions that made possible the McGill symposium and this monograph which describes the Index Emblematicus. The Social Sciences and Humanities Research Council of Canada and McGill University funded the symposium itself, which brought together a group of scholars active in the field of emblem studies to discuss the desirability and explore the feasibility of an Index Emblematicus. Barbara Becker-Cantarino (University of Texas at Austin), Martin Bircher (McGill University/Wolfenbüttel), G. Richard Dimler, S.J. (Fordham University), Lorelei Robins (University of Manitoba), and Alan Young (Acadia University) all presented papers and participated fully in the discussions. Bezalel Narkiss (Jerusalem/The Institute for Advanced Study, Princeton), one of the editors of the *Index of Jewish Art*, provided much valuable advice from his experience indexing illustrated manuscripts. Among the many colleagues who made the winter journey to Montreal in order to participate constructively in our deliberations, I should like to mention especially F. David Hoeniger (University of Toronto), Tony Raspa (Université du Québec à Chicoutimi), and Sharon Adams (McMaster University).

Literary scholars dealing with the emblem can be blind to some of the visual implications of this mixed form. Among the art historians who have helped me see more clearly, and in one way or another have influenced the conception of the Index Emblematicus, are Karl-August Wirth (Munich) and my McGill colleagues Rosemarie Bergmann, George Galavaris, and Thomas Glen. Unfortunately William S. Heckscher was unable to accept our invitation to attend the symposium, but nonetheless graciously gave of his time by writing at length of his experience with the Princeton Emblem Project. I wish to thank him warmly for his encouragement.

The publication of this monograph owes much to the goodwill and assistance of several individuals and institutions. I should like to thank the Wilfrid Laurier University Press for their cooperation and the English Department at Wilfrid Laurier University who provided the secretarial facilities for the preparation of the copy for the Press. A word of personal thanks goes to Peter Erb and the Chairman of the

English Department, Professor Gary Waller. Last but not least I
gratefully acknowledge the financial support of McGill University
through its Humanities Research Fund and the Faculté des études
avancées et de la recherche of the Université du Québec à Chicoutimi.

Finally, since the emblems reproduced in the volume are taken
from old publications, many of them not in good condition and in remote
locations, the quality of reproduction is sometimes less than might be
desired.

PREFACE

This book arose directly out of a symposium held at McGill
University, December 4-6, 1978, which discussed my proposal for the
creation of an Index Emblematicus. The actual idea, however, took
shape during the year 1976/77 that I spent at the Herzog August
Bibliothek in Wolfenbüttel, Germany, engaged in a study of various
aspects of the emblem tradition. Over the years mine had been the
experience of the many who need to consult emblem books, but who have
been frustrated by the relative inaccessibility of these rare books,
and of the many seeking specific emblem motifs or concepts and whose
search is made difficult by the mass of material. The idea to estab-
lish both an emblem archive at the Herzog August Bibliothek and an
Index Emblematicus gradually crystallized through discussions with
colleagues and I presented these proposals to a conference held at the
Library in July 1977. Both suggestions were received positively.

My proposal was discussed again at a second conference in
Wolfenbüttel dedicated to "Text und Bild im 17. Jahrhundert," held
March 1978. At that time an international group of scholars from vari-
ous disciplines set up an Advisory Committee representing the two
Wolfenbüttel Arbeitskreise for Renaissance and Baroque to consider the
matter further. The Committee includes Martin Bircher, August Buck,
Peter M. Daly, Albrecht Schöne, Carsten-Peter Warncke, and Karl-August
Wirth. I was asked to continue work on an index model and carry out a
pilot study. The McGill symposium, made possible by grants from McGill
University and the Social Sciences and Humanities Research Council of
Canada, was in a very real sense a continuation of the explorations
begun at the Herzog August Bibliothek in July 1977.

The basis of the symposium was a position paper in which I both
discussed some of the problems involved in describing emblems and also
presented a characterization of the Index Emblematicus. I have expanded
these for publication, but not altered them substantially since they
describe in general terms the problems and the procedures involved in
the analysis and indexing of emblems, no matter what final shape the
Index Emblematicus may take. Indeed, in the final chapter I provide a
summary of the results of the symposium workshop where alternative
models were discussed. These discussions took up many of the points
raised by the participants in the symposium and which are documented in

the papers published here by Lorelei Robins, Barbara Becker-Cantarino, Alan Young, G. Richard Dimler, S.J., and Peter Erb.

LIST OF FREQUENT ABBREVIATIONS

E or Henkel/Schöne Henkel, Arthur and Schöne, Albrecht. *Emblemata. Handbuch zur Sinnbildkunst des XVI. und XVII. Jahrhunderts* (Stuttgart, 1967), Ergänzte Neuausgabe (Stuttgart, 1976)

IE Index Emblematicus

ICA *Index of Christian Art* (Princeton University)

IJA *Index of Jewish Art.* Ed. Bezalel Narkiss and G. Sed-Rajna (Paris and Jerusalem, 1976)

A NOTE ON TRANSLATIONS

All translations were provided by the authors or editors, unless otherwise indicated.

INTRODUCTION

The Emblem

In 1531 the Italian lawyer Andreas Alciatus published a small,
poorly illustrated book of emblems, the *Emblematum liber* (Augsburg,
1531), and unwittingly launched a new genre that was to become immensely
popular. Alciatus himself has gone through over 170 editions, Francis
Quarles's *Emblems* have appeared at least 44 times, and Otto van Veen's
Moralia Horatiana runs to at least 34 editions. Emblem books were
frequently reprinted, augmented with learned commentary, and translated
into various languages. According to the bibliographies of Mario Praz[1]
and John Landwehr,[2] over 600 authors produced about a thousand titles
which were issued in over two thousand editions.

The book form is, however, only one medium through which the
emblematic combination of text and picture was disseminated. Emblematic
designs were incorporated into almost every artistic form; they are found
in stained glass windows, jewelry, tapestry, needle work, painting, and
architecture. Veritable emblem programmes may be found adorning the
walls of private residences[3] and ecclesiastical buildings.[4] Emblems were
used as theatrical properties in dramas and street processions. Poets
and preachers, writers and dramatists frequently employed emblems and
emblem-like structures in both the spoken and the written word. The
emblem thus helped to shape virtually every form of verbal and visual
communication during the sixteenth and seventeenth centuries. The emblem
is consequently a cultural phenomenon of major significance. Like other
baroque forms the emblem, however, fell into disrepute and then into almost
total neglect during the eighteenth and nineteenth centuries.

Revival of Interest in the Emblem

The general reawakening of scholarly interest in the emblem is
witnessed today by the reissuing over the last two decades of a number
of emblem books, and by the publication of the Henkel/Schöne *Emblemata.
Handbuch zur Sinnbildkunst des XVI. und XVII. Jahrhunderts* (Stuttgart,
1967).[5] There have also appeared a number of critical studies of emblem
theory, the relationship of the emblem to other forms of illustrated
literature, and appreciations of individual emblem writers. Art histo-
rians in general and students of iconography in particular have become

1

increasingly aware of the potential importance of emblems in the interpretation of art.

During the last ten years or so there has been a remarkable growth in scholarly interest in the emblem in German studies. This may be dated to the acceptance of the now standard work by Albrecht Schöne on *Emblematik und Drama im Zeitalter des Barock* (Munich, 1964), which was followed by an important monograph by Dietrich Walter Jöns, *Das "Sinnen-Bild." Studien zur allegorischen Bildlichkeit bei A. Gryphius* (Stuttgart, 1966).

English literary criticism has taken note of the emblem at least since the pioneering work of Henry Green in the 1870s,[6] although the absence of a solid theory of the emblem undermined the validity of some of the results, especially when English scholars have pursued influences and sources.

An indication of the extent of present interest in the emblem and in emblematic qualities of literature may be gained by consulting the recently published *Supplement* to the Henkel/Schöne *Emblemata* and my study *Literature in the Light of the Emblem* (Toronto, 1979).

We now recognize in the emblem an important expression of the cultural life of the Renaissance and the Baroque, reflecting a panoply of interests, ranging from war to love, from religion to politics, from social mores to alchemistic mysteries, from encyclopedic knowledge to pure entertainment. Emblems are also a repository for the symbolic lore of the period, and its interpretation.

The Need for an Index Emblematicus

Although it is evident that the emblem is becoming increasingly important in the study of renaissance and baroque culture, research into things emblematic is still hampered by the relative inaccessibility of the emblem books themselves. Efforts are being made in several places to ameliorate the situation. The Herzog August Bibliothek in Wolfenbüttel, Germany, is embarking upon an Emblem Project, aimed primarily at cataloguing its own holdings and completing the collection by procuring titles listed in the existing bibliographies. In this way the HAB hopes to establish a complete collection of all emblem books. The Princeton Emblem Project has a similar bibliographical mission. The Henkel/Schöne *Emblemata* itself has made available, to libraries and individual scholars who can afford it, a small emblem collection.

A serious *desideratum* is a large-scale systematic index to the emblem. The "Survey of German Research Tool Needs" carried out in 1977

I would, therefore, suggest at the risk of becoming too special-
ized and differentiated that there be a way of distinguishing whether
the meaning of the motif is the meaning of the emblem or whether it has
its own meaning. I would also recommend in conjunction with this idea
that there be a distinction of interpretation and representation. We
may take the two trees mentioned above as examples: In Borja (9) the
tree is interpretational, extending to all facets of overabundant life.
In Covarrubias (10) the pigeon is sitting in a tree which is nothing
more than the tree. Every motif is either representational or interpre-
tational or both, and I believe this difference is important enough to
merit separate categories.

The second and perhaps even more difficult problem concerning
the written text was *what* to include. We may take de la Perrière's em-
blem 44, which shows an eel fisherman stirring up the waters of a river
with a stick in order to catch some eels (see Illustration 7). In the
epigram he is compared to rogues who prefer troubled times which are
conducive to their roguery. It was previously suggested in our working
paper that the IE include unpictured but mentioned concepts directly re-
lated to the meaning of the emblem or extending the representation.
Covarrubias (I,7) provided the example of the honeycomb which appears

Illustration 7 Guillaume de la Perrière, *Le Theatre des bons engins*
 (Paris, 1539), No. 44.

only in the epigram and is an extension of bees and helmet. However, in
this de la Perrière emblem, is the happiness of rogues in troubled times
directly related to the happiness of a fisherman who catches his next
meal by stirring up the mud of a river bed? It is metaphorically re-
lated, and I suppose in this sense emblematically related. But I do not
see that it is directly related in the same sense as a burning fire is
directly related to a burning passion, or a beehive is a logical repre-
sentational and interpretational extension of helmet and bees. Yet it
is impossible to exclude the rogues enjoying the troubled times, because
the emblem means that, rather than a fisherman procuring his next meal.
In fact, many epigrams include motifs and concepts which are directly
related, not to the *pictura,* but to the meaning as a whole, and regard-
less of whether that meaning was stated anywhere or not, it seems nec-
essary to include such information. Another example is de la Perrière
45, which shows crows as scavengers (see Illustration 8).

Illustration 8 Guillaume de la Perrière, *Le Theatre des bons engins*
(Paris, 1539), No. 65.

The epigram says flatterers of the court are worse than crows,
as crows only attack a corpse whereas flatterers attack living men, and
the last words of the epigram are "from these flees a good and wise
prince." Therefore "prince, wise" is both motif and meaning, related to

the meaning of the emblem as a whole. "A good and wise prince avoids flatterers," however, is not directly and immediately associated with the meanings of the motifs in the *pictura* as they would be reported in the Index. Nonetheless "prince" relates directly to the emblem. It should appear in the IE.

Here again, we must consider that the possibilities of the emblematist and artist for representation are infinite as are the extensions of the interpretations, and it is here that the analyst must realize that often the choice of image and/or interpretation is not as exclusive as we would like to believe. With regard to crows and corpse, this same picture could have been used to exemplify anyone regarded as a malefactor to living people and whom the emblematist considers worse than crows. From many emblems we could choose unfaithful friends ("a wise man avoids false friends"), a vicious wife ("a wise man avoids marriage"), and spoiled children (in fact, this emblem is much closer to a Spanish saying, "si crias cuervos, te sacarán los ojos," i.e. literally, "if you bring up crows they'll pluck out your eyes"). However, in de la Perrière's case, we emphasize "prince" since we know that often these emblem books were handbooks for and about princes, and we realize that in this instance, the author's choice of prince was intentional and pointed, especially since it is the last word in the epigram. Perhaps this is so obvious it need not be mentioned. It only becomes significant when we realize that sometimes the emblematist changes the motifs or concepts in the epigram while keeping the same picture in later editions of his work. De la Perrière is an excellent example. He made additions or subtractions in various emblems of the first two Janot editions of *Le Theatre des bons engins*. One is the horse, mentioned by Daly, in emblem 7, excluded in the second edition; there is emblem 23, which in the first edition mentions Scipio, replaced by Hercules in the second edition; emblem 51 of the first edition mentions the pilgrim going to England, edition two drops England but adds as a sign of his pilgrimage, that the pilgrim sells his sea shells, reference no doubt to the road to St. Jacques and the sea shell which was the symbol of pilgrims. Here, the index analyst must make a choice: do I include horse, England, Hercules, Scipio, shells? I fear that if one were to look at all editions, the Index would end up with seven million cards instead of two million. Actually, the problem is not so much size as principle. Whereas the inclusion of "prince" is indispensable, "horse" could be excluded, especially since the emblem writer himself chose to exclude it in his second edition.

The decision to include--or exclude, for that matter--motifs from the epigram or commentary raises the question of priorities, and, unfortunately, involves subjective judgments. I may say princes are important, because there are many emblems which direct themselves to and about princes. I may say horses are not important in the case of de la Perrière, as the emblem writer excludes them himself. But one does not always have two or three editions with which to work, and in any case, the emblem writers do not always modify their texts. Therefore, we are faced with the "embarras du choix": Just what is relevant from the written text? As I have just shown, with reference to de la Perrière emblem 44, we must include the happiness of rogues, but must we include all motifs mentioned in the text even if they extend the representation?

It seems to me there are two ways in which a motif may work--"vertically" and "horizontally." By the former I mean the introduction of new and different interpretations and I believe all of these elements from the written text, either epigram or commentary, should be included. I will use Covarrubias's emblem 8 to illustrate a horizontal motif, which essentially brings "more of the same" (see Illustration 9). The picture shows a sun shining equally on Babylon and Jerusalem. The writer then goes on to state that the sun shines on the lamb (good) and the goat (evil), on the wheat (good) and on the chaff (useless), on the oat (good) and on the husk (useless), on the gold (good) and on the slag (useless). Covarrubias might have chosen nut and shell, banana and peel, work and reward, suffering and glory--any of these would have been appropriate, and they would not add to nor detract from the meaning of the emblem as a whole, nor change the meanings of the three motifs in the *pictura*: the sun, Babylon, and Jerusalem. I would not include as motifs goat, gold, husk, wheat, and lamb in the analysis of this emblem.

The inclusion and classification of such motifs are not problematic in themselves, but I consider them unnecessary. And, I suspect, so may the emblem writer himself: de la Perrière in number 7 was concerned to show that a man would be foolish to antagonize anger, and, of course, whether such a man goads an angry person or an angry horse or other animal is irrelevant, therefore de la Perrière could afford to drop the reference to the horse. In fact, when Covarrubias has a poised arcabux (No. II, 11) and says in the motto "don't touch me" he means the same as de la Perrière's soldier thrusting the sword into the fire (see Illustration 11), and this concept is even more graphically represented in emblem 92 of Georgette de Montenay's *Emblemes ou Devises Chrestiennes*

Illustration 9 Sebastian de Covarrubias Orozoco, *Emblemas Morales* (Madrid, 1610), Book I, No. 8.

(Lyons, 1571), where a man with bellows is fanning another man who is already on fire. The emblem seems to revolve around a basic meaning; sometimes the *pictura* represents directly this meaning, sometimes the reader infers it from the *pictura*, and at other times he deduces it from the text, with a passing reference to the *pictura*. Often, the emblematist brings many examples to reinforce his picture or epigram or motto. These repetitive non-significant motifs could be omitted from the IE. One more example from Covarrubias will illustrate the point: in emblem 3, Book II, a rose is encircled by a snake biting its own tail. Without looking further than the *pictura*, we know that the rose or flower is ephemeral beauty and the snake, time. Covarrubias tells us this in his epigram. He also informs us that feminine beauty perishes, and that green pastures must fade by winter time. These are directly related to the emblem and *pictura*, but they do not add new information.

My analysis of Covarrubias included two groups of emblems, taken from the first and second *Centuria*. It should be noted here parenthetically that one consistent piece of information present in every individual emblem commentary was the source of the motto or meaning. Thus, if we were to index sources, we would need to consult the commentary in Covarrubias. Since there is a source quoted in every instance, it must be of some importance to this emblematist. However, this is a question of principle that concerns the IE, not the commentary. To return to my analysis, I consulted the fourteen cards from the commentary to the first group of twenty emblems. Nine of them fell into the category I would call horizontal, i.e., they gave further examples of the meaning, but neither added a new interpretation nor elucidated the motifs in the *pictura* for the first time. I called them the "more-of-the-same-variety." For example, Book I, emblem 14 shows a shepherd milking an ewe, while her lambs watch nearby (see Illustration 10). The epigram warns us that if we milk the ewe dry, her lambs will suffer and her wool will be less fine. Therefore greed is unwise. The commentary says that all greedy men are reprehensible, including kings, prelates, and nobles who "milk" their subjects dry. Since the meaning in the epigram is directed to all men, I do not think it necessary to have separate cards for kings, prelate, and nobility, but rather one for "greedy man," or "greed."

On the remaining five cards I had information which might be called vertical. I considered as such anything that expanded any motif, or gave a new insight into the meaning of the emblem. In Book I, emblem 3, which shows bees gathering honey and beetles crawling on the ground, Covarrubias states in his commentary that beetles are like sinners, since they die unless they can have putrid food. In the above-mentioned emblem 8 showing the sun shining on Jerusalem and Babylon, the author expands his epigram in the commentary, where he says that although the bad may seem to enjoy a good life here on earth, and even though they sometimes may do a good deed, they will never enjoy eternal life. As an example he mentions the Egyptian midwives who hid the Jewish babies from Pharoah. He goes on to say that this was a good deed, and for it these women were rewarded on earth, but, as the Egyptians did not recognize the one true God, they were not rewarded with everlasting life. I considered this sort of expansion relevant.

Another interesting example is emblem 16 which shows a crown above a book, intepreted by the commentary "king by succesion [book] rather than by appointment."

CENTVRIA I. 14

PECORI·ET·LAC·SVBDVCITVR
SVCCVS AGNIS
ET

EMBLEMA. 14.

Goza el paſtor, la lana, leche, y queſo,
De la ouejuela manſa, y aunque cria
Su tierno corderito, no por eſſo,
Le dexa de ordeñar lo que ſolia:
Suele a vezes perderſe en el exceſo,
Quien pudo coſeruarſe en medianiა,
Dexe a la madre xugo, al hijo leche:
Si quiere ꝗ el eſquilmo le aproueche.
C 2 Los

Illustration 10 Sebastian de Covarrubias Orozoco, *Emblemas Morales*
 (Madrid, 1610), Book I, No. 14.

Covarrubias warmed to his task, writing longer commentaries in
the second *Centuria*. Also, I found them more explanatory of the pic-
tures than elaborative of the epigram. Again, I had fourteen cards but
for only fifteen emblems. Fewer of these cards can be considered hori-
zontal, as they add new information. For example, Book II, emblem 8
shows a swan seeking refuge in the reeds of a river, and it is in the
commentary that Covarrubias tells the story of Phaeton, Jupiter, and
Cygnus. Perhaps these should be considered source but since the story
elucidates the picture I added it to my commentary cards. It is often
difficult to draw the line. Again, perhaps we may take our direction
from the commentator: rather than just naming the source, he recounts
the tale; it therefore must have seemed particularly important to him.

Borja's emblems were problematic because I had to consider the
written text as both commentary and epigram. As the emblems are so

simple, it was not difficult to recognize the meaning of the emblem as
a whole by a mere perusal of the *pictura* and motto. However, in spite
of the fact that the text served as both epigram and commentary, I put
all concepts and motifs found in the text on commentary cards. Since
Borja tends to be not only verbose, but repetitive, there were many
horizontal motifs which I deemed could be excluded; but it was obvious
that many times his commentary expanded the meaning of the emblem. For
example emblem 3 shows a turtle, and Borja proceeds to give us a quasi-
existential lecture, saying if you eat a bit of turtle it is harmful,
you must therefore eat a lot; similarly, when you act, commit yourself
wholly, since to act in bad faith is morally wrong. This sort of infor-
mation is, of course, relevant. In most of Borja's emblems the commen-
tary is necessary, since commentary replaces epigram.

It appears that commentary may have different characteristics
and functions depending on the author. I do not believe that any emblem
of Covarrubias was drastically affected by his commentary. Aside from
the information concerning sources, there were no instances of commen-
tary changing the meaning of an emblem, or elucidating it for the first
time, although as we saw there were examples of a relevant extension of
representation and interpretation. I believe this type of information
could be useful for those who would consult the IE. However, I would
exclude from the IE motifs of the "horizontal" variety.

If the commentator is not the author, I would not include in
the IE information gleaned from his writings. The emblem must stand as
the original writer conceived it. If the meaning of his images is
obscure, then we may assume either that this was the writer's intention,
or incomprehension is the result of our ignorance. If he intended them
to be recondite, then we are to interpret them. Commentary by someone
other than the author was perhaps intended to demonstrate the erudition
of the commentator, and although such elaborations may, indeed, be
interesting and informative, I do not believe they should be included
in the IE. On the Index card of authors, we could indicate commented
editions which the user may consult if he wishes.

Commentary of the Borja type, where it doubles as epigram, must
be subjected to close scrutiny, and only the most relevant concepts and
motifs extracted, i.e., those of the "vertical" variety.

Finally, I should like to argue for the inclusion of all con-
cepts in the written texts--motto, epigram, commentary--those directly
related to the *pictura*, and those which may not be directly related to
the *pictura*, but relate to the meaning of the emblem as a whole. This

appears to me to be most important if the information made available through the IE is to be all-embracing, and if the user is to have a complete reference to a given emblem.

TOWARDS AN INDEX EMBLEMATICUS

Peter M. Daly

Before describing the form that an IE might take, its organization and arrangement, perhaps some preliminary remarks on the nature of the emblem would be in order. One's conception of the emblem as a genre will not only influence the interpretation of individual emblems and emblem books, it will also shape attitudes to structural analogues in the purely verbal art of literature.[1] Similarly, the decision regarding what to index and how to make that information available to a user of the IE arises at least in part from an implicit theory of the emblem as a genre.

Since I have considered more recent theories of the emblem elsewhere,[2] some general comments will suffice here. With its mutually dependent picture and texts, the emblem is a special form of *ut pictura poesis* literature. The exact nature of the interaction of the verbal and visual has, however, been a subject of disagreement for over a century. Henry Green had a somewhat simplistic view of the way picture works together with texts. In the "Essays" that accompany his edition of Whitney's emblems, Green suggests: "The motto gives the subject, the device pictures it, the stanzas clothe it in language more or less poetical..." (p. 233). Although too simple, Green's description is at least neutral. Especially among art historians the view was common that the emblem is characterized by wit and enigma. The epigram was thus regarded as resolving an enigma that is produced by the combination of motto and *pictura*. In their long and informative article in the *Reallexikon zur deutschen Kunstgeschichte*, vol. 5 (Stuttgart, 1959), Heckscher and Wirth express this notion with admirable succinctness: "In the emblem one is dealing with the combination of the word of the lemma with the picture of the icon which produces an enigma, the resolution of which is made possible by the epigram" (Col. 95). English scholars have tended to share this view, criticizing the arbitrariness of the emblem,[3] and the supposed lack of "necessary likeness" between pictured motif and stated meaning.

Liselotte Dieckmann offers a more flexible description of the interaction of picture and texts in terms of "mutual elucidation." In an essay on renaissance hieroglyphics she writes: "The three parts should elucidate each other. The picture is not an illustration of the

text, nor the text an explanation of the picture; their purpose is mutual elucidation of an idea."[4] In his study *Emblematik und Drama im Zeitalter des Barock*, second edition (Munich, 1968), Albrecht Schöne regards the individual parts of the emblem as fulfilling a "dual function of representation and interpretation." He writes: "One is probably more likely to do justice to the variety of forms, if one characterizes the emblem in the direction that its three-part structure corresponds to a dual function of representation and interpretation, description and explanation" (p. 21). This is the most flexible and neutral definition advanced to date, and can accommodate a great variety of emblems. Schöne further refines this general definition by giving instances of the different ways in which the texts and picture contribute in this dual function of representation and interpretation:

> Inasmuch as the *inscriptio* appears only as an object-related title, it can contribute to the representational function of the *pictura* as can the *subscriptio*—if part of the epigram merely describes the picture or depicts more exhaustively what is presented by the *pictura*. On the other hand, the *inscriptio* can also participate in the interpretative function of the *subscriptio*, or that part of the *subscriptio* directed towards interpretation; through its sententious abbreviation the *inscriptio* can, in relation to the *pictura*, take on the character of an enigma that requires a solution in the *subscriptio*. Finally, in isolated instances the *pictura* itself can contribute to the epigram's interpretation of that which is depicted, when, for example, an action in the background of the picture with the same meaning helps to explain the sense of action in the foreground[5]... (p. 21).

It is this broad and catholic characterization of the emblem genre that has guided most studies of emblems and of the emblematic quality of literature per se written by German scholars since 1964, when Schöne's seminal work was first published.

As far as the IE is concerned, it matters little which of the several theories of the emblem one accepts. All theories recognize the unique interplay of text and picture that constitutes the essence of the emblem. An Index that ignores either aspect has done violence to the genre. Thus the IE must provide access to the visual and verbal materials of the emblem, in this way reflecting that dual function of representation. The question is not one of principle, but of degree. How far can the IE go in indexing words and pictures?

1 *The Principles of the Index Emblematicus*

1.1 *Access to the Pictures and Texts*

The first principle of the IE is to provide the user with access
to the chaotic mass of information contained in the emblem books, and
that means both the visual and verbal elements. But in addition to the
three-part emblem the writer often incorporated a commentary that cannot
be overlooked. Just how much of this information should be included in
the IE could be debated until cows fly and crows give milk. The extreme
positions are clear, as always. Neither texts nor pictures can be
ignored, but it is not possible to index and concord everything either.
Some limits have to be imposed. This is the central question since the
IE only makes sense both as a project and as a kind of information sys-
tem if a large number of emblem books can be described and indexed with-
in a reasonable span of time.

It has already[6] been suggested that, as far as the picture is
concerned, only semantically significant motifs--however defined--should
be indexed; also that commentary be included to the extent that commen-
tary is drawn into the representational and interpretational functioning
of the emblem. With regard to the texts I would suggest limiting the IE
to key words, both representational and interpretational. These admit-
tedly very general observations will be considered more closely in the
following pages.

1.2 *Alphabetical not Classified*

Unlike the *Index of Christian Art* (ICA) and the Henkel/Schöne
Emblemata, which are classified indexes, the IE will be strictly alpha-
betical, like most published concordances. That is to say, members of
one group will not be brought under one heading, e.g., ash, oak, pine
under "Tree." This would go a long way towards eliminating the need for
cross-referencing, which is a time-consuming job for indexers. If the
IE is to be practical as a project, it must be simplified as far as is
compatible with scholarly accuracy and user convenience. There is a
danger that an index system can become sophisticated to the point of
being inconvenient for the occasional user. A high degree of complexity
and refinement almost inevitably means low production in terms of re-
sults that can be made accessible to users. Ultimately, an index system
is not an end in itself; it is justified only by its value to users.

1.3 *Information provided by the Index Emblematicus*

The minimum of useful information which the user of an Index Emblematicus can expect is the following:

1. Identification of the pictorial motif
2. Exact reference
3. Meaning of motif
4. Description of picture context
5. Motto

Whether the IE should describe and index emblem settings is a moot point.

1.4 *Index Systems*

The IE, as presently conceived, will be an Index to both words and pictures. However, the basis would be the description and analysis of the *pictura* and its meaning. Thus the primary Index would be the Motif Index, by which is meant an Index of pictorial motifs, both the larger clusters such as "Eros holding a peachbranch, finger to his lips" and the individual, single motifs, such as "peach fruit."

Parallel to this Motif Index there should be created a Word Index, which would be based on the concepts and meanings that have been established for the motifs. Thus the user has access to both the representational and interpretational aspects of the emblem as a whole.

Finally, it would be useful to set up an alphabetical listing of all mottoes, and a concordance to the key terms.

1.5 *The Placing of the Photographic Material*

The ICA maintains a separate file of photographs to which all the other files refer, because of the complexity of the material and the sophistication of the classification systems. On the other hand, the *Index of Jewish Art* (IJA) reproduces the photograph of the illuminated manuscript on each subject card. If not prohibitively expensive, this would be an ideal procedure for the IE. The model proposed here is an adaptation of the subject card used by the *IJA*.

1.6 *The Index Card for the Index Emblematicus*

Utilizing a modified version of the card developed for the *IJA*, the Index card might look like the diagram on the following page.

2 *The Information on the Index Card*

To some extent the information provided will depend on the physical make-up of the IE, on the placing of photographic reproduc-

Motif	Author		Short Title		p./no.
	date	place	language	no.of ill.	no. of cards
Meaning					
Description of Subject			photograph of emblem		
Motto					

tions, and on the use or non-use of computer-generated indexes to accompany the primary index card.

2.1 Reference

As in any concordance or reference work, the identification of reference must be precise and systematic. No one system of reference will answer every user's needs. If one has a historical interest, then that overrides the question of author, theme, and language; however, if one is interested in the emblems in a specific language, then that consideration takes precedence over such questions as the historical development of the genre. The important thing, it seems to me, is to hit upon one simple, systematic method, and leave it to the individual user to bring his specialized questions to the Index. Such a simple system would arrange entries alphabetically, chronologically, and according to language, in that descending order of importance. Thus, all the eagle motifs would be found under E, sorted firstly according to the alphabet; within a group according to date, thus bringing the earliest to the front; and finally by language, which again could be arranged alphabetically, for the sake of simplicity and consistency.

2.2 *Clear Identification of Motif*

Each pictorial motif must be clearly identified. As far as is
possible nouns should be used to name the motifs which will appear in
the IE. Where necessary the nouns must be modified by descriptive
adjectives or other modifiers. Thus we can expect to find: "dog,"
"dog, barking at moon," "dog, biting man," "dog, eating," and so on.

But what precisely is meant by motif? It is well known that the
scope of representation in emblem pictures ranges from the individual
motif alone printed on an empty page, through loose groupings of several
motifs, to complex or compound pictures, and finally there are pictures
which contain two or more groupings that in turn contain a number of
individual motifs. As an instance of a loose grouping we might take the
Camerarius emblem which depicts an eagle sitting on a globe which stands
on a cube (cf. E 760). Each motif remains separate and yet forms part
of the larger group or cluster which produces the general meaning, "fore-
sight and concern of the ruler." For the IE the key motifs are "eagle,"
"globe," and "cube"; thus the Camerarius emblem would appear three times
under each of these separate headings.

By compound motifs I mean, for example, the compounding of an
eagle with lightning as we find it in Borja's emblem 49, showing a bundle
of lightnings superimposed on the figure of an eagle (cf. E 758). A more
complex instance is Saavedra's emblem 22 which features an eagle holding
a bundle of lightning combined in a double figure with an ostrich hold-
ing a horse shoe (cf. E 762).

It would be unwise for several reasons to designate all in-
stances of eagle, whether the bird appears as a single motif, compounded,
or part of a larger grouping, simply as "eagle." Firstly, the sheer
mass of material would make the category unwieldy. The Henkel/Schöne
Emblemata contains some forty-five instances of "eagle"; if the handbook
selection is representative in terms of the distribution of motifs in
emblem books, then we can expect at least twenty or thirty times this
number, if all emblem books were to be indexed. Secondly, such a sim-
plified listing of motifs would not reflect the frequently complex
arrangement of motif clusters in emblems. Thus, the IE should contain
both the cluster and the individual motif. For instance, Alciatus's
emblem 15 (Paris, 1542) shows the figure of a naked genius, whose right
hand is weighted down by a stone, pointing with his winged left hand up-
wards towards a cloud in which a prince or prelate appears. Motto and
epigram interpret the compounded figure, the complete cluster of motifs,

as meaning "poverty is an obstacle to native genius." The central clus-
ter might be identified as "Genius, right hand weighted down, points
with winged left hand upwards." In addition to this entry under "genius"
the IE would also contain cards for "hand, winged," "winged hand," "hand,
weighted down by stone," "stone, weighting down hand," "prelate (?), in
cloud," "prince (?), in cloud."[7] The question mark indicates an uncer-
tain identification. In this way both the cluster and the individual
motifs can be retrieved, even though the single motif may be combined or
compounded with other pictorial elements.

In order to simplify matters and reduce the number of motifs
incorporated in the IE, certain well-known groupings need not be broken
down further. A personification like Eros, who is regularly shown with
wings, quiver, arrow, and bow, or one or more of these attributes, could
be identified simply as "Eros proper." There would then be no need to
list "arrow," "bow," "quiver," and "wing" separately. Such attributes
need only be mentioned where they play a special role, as is the case
when Eros fires an arrow or breaks his bow. Any such commonplace symbol
that is made up of unchanging constituent parts could be so treated.
For example, Mercury's staff could be so named and such component parts
as "snakes" and "wings" need not be specially identified and indexed.
Since the emblem has a dual function of representation and interpreta-
tion, and each of the three parts may be involved in the representational
process, the question naturally arises whether only motifs appearing in
the *pictura* should be indexed.

2.2.1 *The Motif only named in the Text*

Are those motifs only named by the epigram, as part of its rep-
resentational function, to be excluded from the IE? Such motifs, named
but not drawn, are sometimes implied by the *pictura*; they may extend the
representational function of the picture. For instance, Covarrubias
(I.7) has an emblem picturing a skull around which bees fly; they also
enter the skull. This seems to be a variation of Alciatus's bees and
helmet emblem meaning "Ex bello pax" ("peace from war") (Paris editions,
No. 45). The reader attuned to the emblematic tradition may well recog-
nize that the bees have built their hive in the skull, but nowhere is
the honeycomb depicted. The epigram, therefore, extends the representa-
tional function of the *pictura* by naming the honeycomb which is inter-
preted as the "sweetness of the after-life after death."

A more complicated example of this phenomenon may be found in
Francis Quarles's *Emblems*, V, 4: "I am my beloveds, and his desire is

towards me." The *pictura* combines a sunflower and compass needle. The text, however, also mentions a sundial, that is nowhere depicted in the picture. The first four lines of the poem read:

> Like to the Artick needle, that does guide
> The wandring shade by his Magnetick pow'r
> And leaves his silken Gnomon to decide
> The question of the controverted houre,
> First franticks up and downe, from side to side.

As Karl-Josef Höltgen in his recent study[8] suggests, Quarles is probably thinking of the portable instrument combining sundial and compass. The magnetic power of the compass needle gives the sundial its correct position: "The Artick needle ... does guide/ The wandring shade by his Magnetic pow'r." Some detailed knowledge of this instrument, however, is required in order to make sense out of the epigram. The inside lid of the compass box contains the clock face of the sundial; the silk thread ("silken Gnomon") fastened to the opened lid and the floor of the compass box takes the place of the metal pointer of the conventional sundial.

Such unpictured motifs should not be omitted. In order to indicate the user of the IE that those motifs are not contained in the picture, the source in the emblem could readily be identified by adding the symbols (E) for epigram, (M) for motto, and (C) for commentary, were the commentary also to be indexed.

Just how far should the IE go with the inclusion of verbal motifs? Where does representation end and incidental visual illustration of the central theme begin, or how clear is the distinction between what Lorelei Robins calls "vertical" and "horizontal"?[9] Should the IE also include motifs named by the epigram that are not directly related to the *pictura*?

2.2.2 Motif named in the Epigram not directly related to the Picture

De la Perrière's seventh emblem depicts a classically attired soldier who thrusts his sword into a fire. The epigram suggests this is unwise and gives a further example: that of the galloping horse which should not be spurred on. The horse is not depicted in the *pictura*. The question is: do we index the galloping horse? It is a further representational example, named by the epigram, but not related to the *pictura* in terms of image field in the manner in which the undepicted honeycomb is directly related to bees and the skull-bee-hive (see Illustration 11).

7

L E feu de glaiuʒ atiſer ne conuient
 Comme l'on lit au dit Pytagorique,
Lequel ainſi que le propos auient
Sera reduit en ſens alegorique
Ce beau pourtrait clerement nous explique
Que gens irez ne deuonsirriter.
Ains que pluſtoſt les deuons inuiter
A bonnʒ amour par douceur de parole:
Car autrement l'on les fait conſiter
Et enflamber plus fort leur chaude colle.

Pitha-

Illustration 11 Guillaume de la Perrière, *Le Theatre des bons engins*
 (Paris, 1551), No. 7

I believe it should be indexed, since it contributes to the interplay of
description and elucidation that is the emblem. Here the text does what
the pictura accomplishes in other emblems. Pieter Hooft actually draws
Hero and Leander in the background, instead of verbally describing that
story.[10] Daniel Meissner also draws a splendid patrician house damaged
by a storm, instead of talking about it.[11] Jacob van Bruck draws three
scenes, depicting crime, arrest, and execution, instead of describing
these in his epigram.[12]

 Thus far we have quite properly limited our attention to the three
parts of the emblem. However, emblem books frequently have explanations
of the emblems in prose or even in verse, so that this fourth component,
the "Erklärung," as the German emblematists called it, is invariably drawn
into the representational and interpretational functioning of the three-
part emblem. At times the epigrams are short and the commentary almost
assumes the role of epigrams. Such commentary is not necessarily a
"superfluous addition" (Schöne, p. 19).

2.2.3 *The Motif named in the Commentary*

The general question is, to what extent should the commentary be included in the IE? Should the identification of motifs by the commentary be indexed? Does it make any difference whether the commentary derives from the emblem-writer or a later editor, e.g., Claude Mignault in the case of Alciatus? If the IE is an Index to the emblems of certain writers, then subsequent commentary could be excluded, as Lorelei Robins suggests.[13]

Before deciding to what extent commentary could be included in the IE, it might be as well to call to mind what other textual components have been drawn into the workings of the emblem by emblem writers. Many emblem books also contain quotations from classical and theological sources, so that the texts accompanying the emblem may be numerous; they could become a complicating factor in the analysis and indexing of emblems. Quarles's *Hieroglyphicks*, for instance, contain a *pictura* and short Latin motto; on the facing page a Bible quotation introduces a longer interpretative poem, which may partly describe the picture, but invariably goes far beyond it; on a separate page is printed a prose quotation from a theological source or a statement by Quarles, and beneath this we find the epigram, so named.

Many of the statements in these quotations and poems have no direct relationship to the emblem, which was the springboard for further meditational thought. Emblem has become meditation. I can see arguments both for excluding and including the new materials deriving from commentaries, "explanations," and appended quotations. However, on balance, it would perhaps be preferable to exclude new motifs, in order to keep the IE focussed on the three-part emblem. The additional interpretation of the emblem motifs--as distinct from representation--should be considered. I shall return to this question later at the appropriate place.

2.3 *The Meaning of the Motif*

The second function of the emblem is interpretation and elucidation. Meaning is often explicitly stated, but just as frequently it is implied by the pictured motif. The IE must reflect this aspect of the emblem. The question is only how, and to what extent? As I indicated earlier, the second Wolfenbüttel conference, held in March 1978, wisely decided against trying to concord completely the texts of the emblem. However, since the emblem picture cannot be understood without the text,

it seems to me unnecessary and, indeed, inefficient not to use the re-
sults of a close reading of the texts, which will have established the
meaning both of individual motifs and of the emblem as a whole. Where
a word from the text denotes the concept or meaning associated with the
pictorial motif, this should be used. De la Perrière (No. 32) has an
emblem showing an eagle surrounded by flies (see Illustration 12).

DES BONS ENGINS.

3 2
L'Aigl∉ a le cueur de ſi noble nature,
Qu'elle ne veult contre Mouſches contendre
Bien les pourroit mettr∉ à deſconfiture:
Mais ce faiſant, hôneur n'en peult pretendre.
Tout bon eſprit en cecy peult comprendre,
Que contre gens de cueur puſilanimes,
Ne font effors les hommes magnanimes:
Mais aux pareilz taſchent liurer la guerre,
D'auoir vaincu gens de tous points infimes,.
L'on n'en pourroit que deshonneur aquerre.
 Qui

Illustration 12 Guillaume de la Perrière, Le Theatre des bons engins
 (Paris, 1551), No. 32.

The epigram interprets the eagle as "le cueur de si noble nature"
and continues to inform us that the eagle does not fight against the
flies, since victory in the unequal battle would bring him no honour.
The flies are, therefore, "gens de cueur pusillanimes" and also "de tous
poins infimes." For the sake of consistency, and as a means of overcom-
ing the multi-language problem of the emblem (i.e., solving the problem
at the level of organization), the meaning of the motif should be given
in a basic concept in one common language, followed by specific quota-
tions from the text, where available. Thus, de la Perrière's eagle
would produce the meaning "noble man," or "nobility," if English were

the primary language of the Index, followed by the quotation "noble na-
ture" (E).

This naming of concepts accompanied by key words quoted from
texts produces the material from which an Index of Meanings could be es-
tablished that would parallel the Motif Index, somewhat in the manner of
the Henkel/Schöne handbook, with the difference that Henkel and Schöne
base their indexed meanings on their own short statement of the meaning
of the emblem as a whole. The Index of Meanings that I am proposing
would be focussed on the motif, and therefore be complementary to the
Motif Index. Further consideration should, however, be given to pro-
viding information on the emblem-concept, i.e., the meaning of the em-
blem as a whole, which would be in addition to, rather than as a replace-
ment for, the motif meaning. And this partly because there exists a
kind of emblem which does not allow for analysis by motif.

2.3.1 *Problems in the Identification of Meaning*

We occasionally encounter difficulties, of course, in identify-
ing the meaning of a given motif, where the emblem-writer does not ex-
plicitly indicate its implied meaning. However, this is more a problem
caused by the lack of knowledge on the reader's part, or his failure to
recognize implied relationships, than it is a problem in the emblem it-
self. But there are, as was intimated above, emblem pictures that can-
not be divided into component elements, where each motif has a separate
and clear meaning. Emblem pictures depicting an activity can be of this
sort.

An instance of this is Taurellus's emblem D 5 with its picture
of a busy smithy. The motto "Quando micat igne, feritur" ("as long as
it glows because of the fire, it is hammered") is purely representa-
tional and tells the reader that as long as the fire glows, the iron
can be worked. The motto describes in words the content of the *pictura*,
without suggesting a meaning or abstract theme for the emblem. However,
since the phrase is proverbial in most languages--"strike while the
iron is hot"--the verbal image already calls to mind the meaning of
taking advantage of favourable circumstances. The epigram refers to
"occasio" and suggests that success attends the man who can take advan-
tage of the favourable moment.

The *pictura* shows smiths heating iron in a furnace; the iron is
then worked on an anvil. It is impossible, however to equate the indi-
vidual motifs, "fire," "iron," and "hammering," with a discrete and iden-

tifiable meaning. The individual motif has meaning only by virtue of its
combination with the other motifs in an action, which produces one gen-
eral sense. The whole activity of softening metal and then working it
immediately has a recognizable meaning which could be named "favourable
opportunity" (see Illustration 13).

Quando micat igne, feritur.
Ad D. Andream Tucherum Noriberg.

Cum grave candenti molliverit igne metallum
Hoc flectet facili quo volet arte faber.
At si durities pulso fuget igne calorem:
Defessas ludent spesq̃, laborq̃ manus.
Commoda susceptis captata occasio rebus:
Eventu faciles prosperiore facit.

Illustration 13 Nicolaus Taurellus, *Emblemata physico-ethica*
(Nuremberg, 1595), No. D 5.

A comparison with metal-working emblems composed by Rollenhagen
and Wither will make the matter clearer. Whereas Taurellus's picture is
drawn realistically, Rollenhagen features in a stylized, almost hiero-
glyphical manner a hand emerging from a cloud, holding a hammer that
works a piece of metal, placed on an anvil, which itself is raised on a
little hill with a natural scene as backdrop (cf. E 93). The motto "Dum
extendar" ("until I am extended"), although not giving the reader the
theme and meaning of the whole emblem, already indicates an equation of
iron with self, with the "I" of the verb. The reader associates the hand
emerging from a cloud with God, or perhaps Fate, and the purpose of the
hammering is clearly indicated in the epigram, which speaks of bearing
such blows in order to achieve a glorious name. The individual motifs
can be identified and interpreted separately: hand = God; metal = man,
"I"; the hammering = blows of adversity. The Henkel/Schöne handbook
interprets the meaning of the emblem as "purification through the blows
of fortune" (E 93), which, however, fails to take into account the epi-
gram statement concerning a "good name." As might be expected, George

Wither provides the *pictura* and motto with a Christian interpretation, already clearly signalled in the new English motto:

> Till *God* hath wrought us to his Wil,
> The *Hammer* we shall suffer still.

In the first part of his epigram Wither seems to render the more secular message of Rollenhagen's emblem:

> So, he that hopes to winne an honest *Name*,
> Must many blowes of *Fortune* undergoe
> And hazard, oft, the blast of *Evill Fame*,
> Before a *Good-Report* her Trumpe will blow.

But the emblem concludes on a Christian note. The metal is now glossed as gold, which is worked to make men "precious in [God's] Sight." Therefore, Wither's "prayers are":

> Not to be freed from Griefs and Troubles quite:
> But, that they may be such as I can beare;
> And, serve to make me precious in thy Sight.
> This please me shall, though all my Life time, I
> Between thine *Anvill* and the *Hammer,* lie.

In Rollenhagen and Wither the meaning of the individual motifs can be identified and named. With Taurellus this is not the case; it seems only possible to name the general theme, the overall meaning to which the picture gives expression. Perhaps the meaning of the individual motifs can be regarded as identical with the motif as such. The fire represented in the *pictura* means no more than "fire"; the metal depicted is only "metal," and so on. By way of contrast, Wither interpreted metal as "man," very much in the Christian tradition of God causing or allowing suffering to purify base man. Hence in many emblems by Cramer and Mannich, Hugo and van Haeften—to name representatives of Protestant and Catholic traditions—the fire in the furnace is evil or adversity. The problem arises in Taurellus's emblem because we are dealing with a proverbial and general theme, which has been rendered visual through the *pictura* of smiths working metal. Neither the texts nor the *pictura* specifies more precisely the meaning of the emblem. For Taurellus only the action as a whole bears significance; the action is not composed of a collection of separate entities, nor is it analyzed in the manner of a Rollenhagen or Wither. The only way to come to terms with such emblems is to regard the individual motifs as meaning no more than they represent, e.g., fire = fire, and perhaps to add the emblem theme, or meaning of the emblem as a whole, under the rubric "meaning."

To conclude, I believe that it is necessary to attempt to identify the meaning of individual motifs, thus providing for the double

access to the emblem, in its dual function of representation and inter-
pretation. On occasions it may be difficult, indeed, impossible to
identify the meaning of a motif, because the motif may not imply a dif-
ferent meaning at all, in which case either the meaning of the emblem as
a whole, the emblem theme, could be given, or the name of the motif re-
peated to indicate that it means no more than it is. In case of doubt,
the space can be left blank. As an information system, the IE is both
cumulative and correctable. When discovered, errors can be corrected
and blanks filled, as the appropriate information becomes available.

2.3.2. *Identification of Meaning given in Commentary*

I suggested earlier that information on concepts and meanings
provided by commentaries might be incorporated into the Index. The in-
terpretational aspects of commentary might be differentiated as follows:
(1) elucidating clearly the general meaning of the emblem; (2) applying
specifically the meaning already established; (3) offering further spe-
cific examples, which in themselves neither elucidate, nor apply in spe-
cific terms, the meaning of the emblem. Covarrubias's use of Gideon
would be an example; it belongs to the concordance function of the com-
mentary (Covarrubias I, 21, [E, 566]). Of these three functions only the
first two appear relevant for the IE.

As an instance of the function of commentary in the interpreta-
tion of the emblem we may take emblem 1 in the collection *Hecatomgraphie*
(1540) of Gilles Corrozet (see Illustration 14). The motto "Parler peu
et venir au poinct" is a clear statement of theme, a general expression
of meaning. The theme is also embodied in a picture of archers with
crossbows aiming at a target. The four-line epigram is purely represen-
tational, adding nothing to the meaning expressed in the motto. How-
ever, on the facing page is printed a commentary, comprising three
eight-lined stanzas, which extend both the representational and inter-
pretational functions of the emblem. The first stanza warns in gen-
eral terms against talking too much, whilst the second stanza refers to
lawyers and preachers. The third stanza returns to description of the
pictura. In other words, only the second stanza applies the general
theme of the emblem to these two specific professions. Reference to the
two professions should be incorporated into the IE.

Some commentaries also identify sources and add in the manner of
concordances further instances of the use of the motif (e.g. Lopez,
Mignault). Such information probably need not be considered, since it
resembles the apparatus in historical-critical editions.

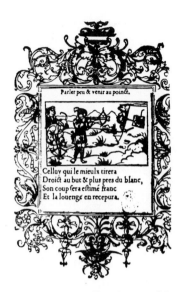

Illustration 14 Gilles Corrozet, *Hecatomgraphie* (Paris, 1540), No. 1.

2.4 *Pictorial Context*

Just as in the concordance to any literary work a word appears
in its natural context, no matter how determined, so also the pictorial
context for the motif should be briefly described. For the *pictura* that
means describing the semantically significant motifs and details. In-
deed, this description is the basis of the analysis and must be carried
out as the first step. As suggested earlier,[14] the description of the
pictura cannot be carried out in isolation; the textual parts must be
fully taken into account. Busier or more complex pictures, such as
Wither's emblem on knowledge (Book, I, 1),[15] can be divided into the con-
stituent clusters, here "scholar," "tree," and "death" with its table.
Each cluster should be described in the manner outlined earlier,[16] using
nouns as far as possible and asterisking those motifs which are to be
treated separately.

The following are examples of index cards prepared for Alciatus's
emblem 15 (Paris, 1542). The first card describes the central cluster
depicting a genius with one hand weighted down, the other winged; the
remaining cards are devoted to one single motif contained in the cluster.

motif	*Author*	*Short title*	15
Genius, right hand weighted down by a stone, points with left hand upwards.	Alciatus	Emblematum libellus	
	date *place*	*language* *no. of ill.* *no. of cards*	
	1542 Paris	Ger/Lat	

meaning
*Poverty hinders *genius. Armuet verhindert manchen kluegen verstand, das er nit furkumbt (M)

description of subject
*Genius, whose right *hand is weighted down by a *stone, points with his *winged left *hand towards the sky, where in a cloud appears a *prelate? or *prince?

motto
Armuet verhindert manchen kluegen verstand, das er nit furkumbt

motif	*Author*	*Short title*	15
Genius	Alciatus	Emblematum libellus	
	date *place*	*language* *no. of ill.* *no. of cards*	
	1542 Paris	Ger/Lat	

meaning
*Genius, wol geborn zu *kunst (E)

description of subject
*Genius, whose right *hand is weighted down by a *stone, points with his *winged left *hand towards the sky, where in a cloud appears a *prelate? or *prince?

motto
Armuet verhindert manchen kluegen verstand, das er nit furkumbt

motif Hand, weighted down by stone		Author Alciatus		Short title Emblematum libellus		
		date 1542	place Paris	language Ger/Lat	no. of ill.	no. of cards

meaning

*Genius hindered by *poverty

Armuet verhindert . . . kluegen

verstand . . . (M)

description of subject

*Genius, whose right *hand is weighted

down by a *stone, points with his

*winged left *hand towards the sky,

where in a cloud appears a *prelate?

or *prince?

motto

Armuet verhindert manchen kluegen

verstand, das er nit furkumbt

motif Hand, winged		Author Alciatus		Short title Emblematum libellus		15
		date 1542	place Paris	language Ger/Lat	no. of Ill.	no. of cards

meaning

*Genius *kunst (E)

description of subject

*Genius, whose right *hand is weighted

down by a *stone, points with his

*winged left *hand towards the sky,

where in a cloud appears a *prelate?

or *prince?

motto

Armuet verhindert manchen kluegen

verstand, das er nit furkumbt

motif	*Author*		*Short title*			15
Winged hand	Alciatus		Emblematum libellus			
	date	*place*	*language*	*no. of ill.*	*no. of cards*	
	1542	Paris	Ger/Lat			

meaning

*Genius *kunst (E)

description of subject

*Genius, whose right *hand is weighted
down by a *stone, points with his
*winged left *hand towards the sky, where
in a cloud appears a *prelate? or
*prince?

motto

Armuet verhindert manchen kluegen
verstand, das er nit furkumbt

motif	*Author*		*Short title*			15
Stone, weighting down hand	Alciatus		Emblematum libellus			
	date	*place*	*language*	*no. of ill.*	*no. of cards*	
	1542	Paris	Ger/Lat			

meaning

impediment of *poverty, *Armuet (M)

description of subject

*Genius, whose right *hand is weighted
down by a *stone, points with his
*winged left *hand towards the sky,
where in a cloud appears a *prelate?
or *prince?

motto

Armuet verhindert manchen kluegen
verstand, das er nit furkumbt

motif	Author		Short title			15
	Alciatus		Emblematum libellus			
Prelate?	date	place	language	no.of ill.	no. of cards	
	1542	Paris	Ger/Lat			

meaning
*Honour, *success
zu hochen *ehren (E)

description of subject
*Genius, whose right *hand is weighted down by a *stone, points with his *winged left *hand towards the sky, where in a cloud appears a *prelate? or *prince?

motto
Armuet verhindert manchen kluegen verstand, das er nit furkumbt

motif	Author		Short title			15
	Alciatus		Emblematum libellus			
Prince?	date	place	language	no.of ill.	no.of cards	
	1542	Paris	Ger/Lat			

meaning
*Honour, *success
zu hochen *ehren (E)

description of subject
*Genius, whose right *hand is weighted down by a *stone, points with his *winged left *hand towards the sky, where in a cloud appears a *prelate? or *prince?

motto
Armuet verhindert manchen kluegen verstand, das er nit furkumbt

3.1 *Index of Meanings*

Thus far the *pictura* and the representational function of the
emblem texts have been the central concern; the interpretational aspects
of epigram and commentary have been regarded largely as ancillary to the
pictura. However, the importance of texts cannot be underestimated; the
word should now be accorded its proper place.

In my initial proposal, presented to the first Wolfenbüttel con-
ference, I suggested that one consider concording the textual parts of
the emblem, possibly with the aid of the computer. The difficulties
would have been many and various. An unlemmatized text produces only a
rough concordance in which conjugated forms ("am," "be," "is," "was")
are scattered throughout the alphabetical listing of words, and homo-
graphs ("kind" as adjective and "kind" as noun) are lumped together. To
overcome this difficulty some form of analysis or lemmatization of the
text to be concorded is unavoidable, as I discovered when preparing with
a colleague a sophisticated concordance to Schiller's *Kabale und Liebe*.[17]
Moreover, with emblem books we have the additional complication of the
many languages used. One theoretical solution would have been to provide
each complete emblem text with a lemmatized English translation, which
would have solved the problem of concording and translating in one step.
Given a two-line input, such as was used in the Schiller concordance,
the computer would sort on the basis of the English lemmatization, but
print out the emblem text in its original form and in its original lan-
guage. For example, the mottoes to Alciatus's emblem 6 (Paris, 1542)
read "Concordia" and "Einigkeyt" ("Unity"); both would appear under the
English key word "Concord"; "Einigkeyt" might also appear under "Unity."
Alciatus's emblem 3 (Paris, 1542) has the mottoes "in silentium" and
"Von stilschweigen" that would be listed under "silence." Needless to
say, the general principle would have required considerable refinement.
Success or failure in scholarly terms--ignoring for the moment practical
considerations--would ultimately have depended on the availability of a
highly specialized and competent programmer. In any case, such a con-
cording activity only makes sense if the total body of textual materials
is to be processed. And here the question of practicability was deci-
sive. Concording, say, 1,000 emblem books? The mind boggles, the com-
puter blows a fuse, and the system goes down, permanently!

If concording of complete texts is one extreme--the Platonic
ideal--then the total omission of all texts--the impatience of pragma-
tism?--is the other. The second Wolfenbüttel conference on "Text und

Bild im 17. Jahrhundert," which was reviewing a much larger project study, concluded somewhat hurriedly that an IE should concentrate solely on pictorial motifs, and the main ones at that. There is, however, a prudent middle position between all and nothing at all, and that is to gloss the pictorial motifs indexed, as a workable minimum. As I indicated earlier, it is impossible to analyze an emblem picture without taking motto and epigram into account. If, as I propose, we add information on the meaning of the motif, using quotations from the emblem texts wherever possible, then this produces the material for an Index of Meanings. Such an Index of Meanings would be usefully restricted to the pictorial motifs already indexed and thus provide for a second systematic approach to the study of the emblem.

Under the key word "Constancy" the user would find listed such motifs as "anvil," "cube," "rock"; under "Concord" he would discover among others Alciatus's lute and crows, discussed earlier.[18] Through the inevitable cross-referencing, a system of approximate abstract equivalents would grow, which would refer the user from "harmony" to "unity" and "federation."

The word index or Index of Meanings could draw on words contained in motto, epigram, and commentary, indicating by means of (E) and (M) and (C) the source of the key word listed.

The cards for the Index of Meanings would have essentially the same format and information as provided by the motif cards. However, there would be no need to have the emblem itself reproduced. Also "motif" and "meaning" would be reversed in position, description of subject and motto remaining unaltered. The following are examples of such "meaning cards" for the Alciatus's emblem (Paris, 1542; No. 15) which was discussed earlier.[19] To simplify matters I have omitted the full reference, description of subject, and motto, which are identical with the motif cards.

concept
genius (kluger verstand [M])
motif
genius, right hand weighted down by a stone, points with winged left hand upwards

concept

honour (hoche ehren [E])

motif

prelate ? in cloud

concept

honour (hoche ehren [E])

motif

prince ? in cloud

concept

kunst (E)

motif

genius, left hand pointing upwards

concept

kunst (E)

motif

hand, winged

concept

kunst (E)

motif

winged hand

concept

poverty (Armuet [M])

motif

genius, right hand weighted down
by a stone

concept
poverty (Armuet [M])
motif
hand weighted down by stone

concept
poverty (Armuet [M])
motif
stone, weighting down hand

3.2 *Setting*

Art historians have argued for the inclusion in the IE of every
pictorial motif, including background and setting. Many motifs, however,
do not have an interpretational or symbolic function; thus, for example,
a sword is often no more than a sword. Whereas in Friedrich's emblem
No. 21 on the subject of justice,[20] a sword placed beneath a pair of
scales clearly refers to the executive arm of justice, the sword in the
hand of Brutus (see Illustration 1) cannot be clearly identified as jus-
tice, or revenge, or cowardice or an even conscience, although one of
these concepts may summarize the meaning of Brutus's suicide for the
emblem writer. Brutus's sword is no more than the accidental means of
his death, not the reason for his death. The IE is to be an index to
the symbolical and allegorical dimensions of the emblem, and not a ref-
erence work in which every pictorial detail is accounted for. Whether
the IE will index the details of background and setting will depend on
whether the pictorial detail in question has a recognizable, relevant
meaning, and whether the background motif contributes to the sense of the
emblem. Usually, background and setting are incidental, they have a
decorative function, and by and large they do not contribute to the
verbal-visual statement made by the emblem as a whole. If something has
to be excluded from the IE, then the dividing line could be drawn here.
Background and setting could be omitted, although some art historians
would argue for their inclusion.

4 *Index of Mottoes*

The Henkel/Schöne *Emblemata* provides an alphabetical list of all
the mottoes in the emblems of the forty-seven emblem books which make up

the handbook. Although useful, the "Motto-Register" has a limited value,
since such a listing is arranged according to the alphabetical value of
the first word in the motto, whereas most users are likely to be inter-
ested in certain concepts and words embedded in the motto. With or with-
out the assistance of the computer, it would be no great task to prepare
an index to accompany such an alphabetical list. The indexer could in-
dicate a lemma for each key word to appear in the index, and the motto
card, with motto reference and key word, could be duplicated for the
number of words indexed. In this manner an Index of Mottoes could be
established almost as a by-product from the close reading of the emblem.

5 The Positioning of Emblem Facsimiles in the IE

If user convenience is the sole criterion, then the photograph
of the emblem will appear on each motif card in the IE, as is the case in
the IJA. However, the number of semantically relevant motifs can range
from one to nineteen, as we discovered with Rollenhagen/Wither, Book I,
1,[21] and that would mean reproducing the emblem as many as nineteen
times. It is my impression that Alciatus's emblems contain on average
five such motifs; consequently the 212 emblems might produce over 1,000
cards. The cost could be prohibitive.

Probably the most effective solution would be to produce facsim-
ile cards of the individual emblems, which would be kept in a separate
file as an unbound book, and in the original order. This would enable
the user to take out the card for a certain emblem, as well as the cor-
responding motif and concept card, for close comparison. The motif and
concept cards have a reference which makes it easy to find the appropri-
ate card with the facsimile of the emblem.

If such a separate Emblem File of photographs were established,
it would become necessary to include the motto on the motif and concept
card, so that the user could see at glance how the motif and its meaning
relate to both the picture and the motto.

6 Emblem Book Concordances and the Index Emblematicus

The IE is essentially a growing index to emblem motifs, mottoes,
and the meanings of those motifs based on the description and analysis
of individual emblem books. In such an Index the individual emblem book
as a whole is lost. That is also one of the unavoidable disadvantages
of the Henkel/Schöne handbook, and any index system. This problem could
be solved. The information cards for the motifs and meanings of an em-

blem-book could be reproduced, the copies filed into the IE, and the original index left as a complete index to the individual emblem-book. Gradually students of the Renaissance and the Baroque would have at their disposal the indexes to individual emblem books as well as the cumulative IE.

7 *Summary of the Individual Indexes of the Index Emblematicus*

Below I indicate schematically the individual indexes that together would make up the complete IE.

7. 1 *Assuming that Photographic Reproductions of the Emblems can be added to each Motif Card.*

THE INDEX EMBLEMATICUS

INDEX EMBLEMATICUS (MOTIFS)

large cards with photo
(C), (E), (M) indicate motif named in text, but not pictured

INDEX EMBLEMATICUS (CONCEPTS)

small cards
(C), (E), (M) indicate source

LIST AND INDEX OF MOTTOES

small cards

INDEXES TO INDIVIDUAL EMBLEM BOOKS

MOTIF INDEX

large cards with photo

CONCEPT INDEX

small cards

MOTTO INDEX

small cards

7. 2 *Assuming the Need for a Separate Emblem File of Reproduction of Emblem Books to which the IE would refer:*

EMBLEM FILE
card reproductions of the emblems of individual emblem-books
Alciatus, Augsburg 1531
Zincgref, Heidelberg 1619

MOTIF INDEX	A	–	Z
cluster- and individual motifs			

CONCEPT INDEX	A	–	Z
concepts and meanings of motifs			

MOTTO INDEX	A	–	Z
alphabetical list and concordance			

NOTES

[1]The most important recent theories of the emblem as a genre will be found in: William S. Heckscher and Karl-August Wirth, "Emblem" and "Emblembuch" in the *Reallexikon zur Deutschen Kunstgeschichte*, vol. 5 (Stuttgart, 1959), cols. 58-228; Albrecht Schöne, *Emblematik und Drama im Zeitalter des Barock*, 2nd. ed. (München, 1968); and Dietrich Walter Jöns, *Das "Sinnen-Bild." Studien zur allegorischen Bildlichkeit bei A. Gryphius* (Stuttgart, 1966).

[2]See Daly, *Emblem Theory: Recent German Characterizations of the Emblem Genre* (Nendeln, Liechtenstein, 1979).

[3]Rosemary Freeman, *English Emblem Books* (London, 1948), pp. 25-29.

[4]Cf. "Renaissance Hieroglyphics," *Comparative Literature*, 9 (1957), 313.

[5]An instance of this is the crucifixion scene in the background to Rollenhagen's pelican emblem. See Illustration 4, p. 11.

[6]Cf. Daly, pp. 6-7 above.

[7]For samples of such index cards, see pp. 45-48 above.

[8]Cf. Karl-Josef Höltgen, *Francis Quarles (1592-1644). Meditativer Dichter, Emblematiker, Royalist: Eine biographische und kritische Studie* (Tübingen, 1978).

[9]Cf. Robins, pp. 22-26 above.

[10]Pieter Hooft, *Emblematum amatoria* (Amsterdam, 1611), p. 24 above.

[11]Daniel Meissner, *Politisches SchatzKästlein* (Frankfurt, 1628), Book 1, emblem 14. The emblem is reproduced and discussed in Daly, *Emblem Theory*, pp. 107-108.

[12]Cf. pp. 9-10 above.

[13]Cf. Robins, p. 26 above.

[14]Cf. Daly, p. 5 above.

[15]Cf. Daly, p. 13 above.

[16]Cf. Daly, pp. 12-13 above.

[17]Cf. Peter M. Daly and Claus Lappe. *Text- und Variantenkonkordanz zu Schillers 'Kabale und Liebe'* (Berlin, 1976).

[18]Cf. Daly, pp. 7-8 above.

[19]Cf. pp. 44-48 above.

[20]Cf. Andreas Friedrich, *Emblemata nova; das ist New Bilderbuch* (Frankfurt, 1617).

[21]Cf. Daly, pp. 12-13 above.

THE *EMBLEMATA AMATORIA*: IMPLICATIONS FOR THE INDEX EMBLEMATICUS

Barbara Becker-Cantarino

Many of the concepts illustrated in love emblems are still with us today, though we may not be aware of their tradition of long standing. Consider the Petrarchist paradox of love as icy fire: "An American firm has marketed a mould in which ice-cubes for cooling drinks can be produced in the form of a naked woman. The chilly lady can thus be melted by liquor and finally consumed by her devotee. The brand-name, 'Miss Sexy-Ice,' makes it clear that this is the ultimate degradation of Petrarch's lofty conception."[1] Lest we be inclined to dismiss this as an example of the crude commercialism of the "New World," consider the following "emblematic" book title from the "Old World": A popular medical discussion for a wide-reading public on--of all things--venereal disease is entitled "Cupid's Poisoned Arrow."[2]

The objective of this paper is to survey a group of thematically related emblem books, the *Emblemata amatoria,* and to apply the criteria for indexing established by Peter Daly to these series in order to develop an analytical method of description for the proposed IE. The *Emblemata amatoria* represent a small and rather well-defined group of emblem books, which originated in an area delimited by geography, in the Low Countries, by a relatively small number of artists and writers, and which flourished during a short period of time from roughly 1600 to 1620, if we disregard the late-comers which mostly copied or derived their emblems from existing collections. One might dispute the significance of such a limited group; however, the *Emblemata amatoria* are collections of pictorial representations and verbal conceits of the major theme of lyric poetry, love. From this affinity derives the significance of this group of emblem books which were also influential for, as well as influenced by, contemporary Dutch art, especially "genre" painting, engravings, and book illustrations. I shall present and analyze a pertinent example, or examples, from each of the major emblem books dealing with love and discuss specific problems arising from indexing these series.

First, a brief survey of the *Emblemata amatoria,* their origin, major representatives, specific audience, and type of emblematic illustrations is in order. Mario Praz had, of course, already recognized their importance and devoted a large part of his chapter "Profane

and Sacred Love"[3] to a survey of the motifs in two major collections,
those of Daniel Heinsius and Otto Vaenius. More recent bio-bibliograph-
ical research, especially that by Breugelmans,[4] H. de la Fontaine Verwey,[5]
and the new publication on Dutch emblem books by K. Porteman,[6] enables us
to be more specific concerning the production, dating, reading public,
and significance of several series. The vogue of love emblems started
in 1601 with the appearance in the Netherlands of a slender, anonymous
volume entitled *Quaeris quid sit amor* . . . ("You inquire what Love is,
what it means to love and to follow Cupid's army. Look into this book,
you will learn: it shows you the garden of love and its delights--look:
the engraver has a gifted hand"). This descriptive Latin title, which
served to advertise the contents, as well as its introductory Dutch poem
"To the Maidens of Holland," are inspired by Ovid's love poetry, while
the twenty-four emblems and accompanying Dutch epigrams draw, for the
most part, on conceits from classical and Petrarchan love poetry. Cupid
is present in all but a few emblems illustrating different aspects of
love in a variety of situations.

 Though never explicitly acknowledge by the Leiden professor
Daniel Heinsius (1580-1655) himself, his authorship of *Quaeris quid sit
amor* cannot be questioned. Not only was the entire content of this col-
lection embodied in Heinsius's *Nederduytsche Poemata* of 1616, already
with its first publication, the introductory poem "To the Maidens of
Holland" was signed by Theocritus à Ganda, his playful pseudonym. The
Greek name Theocritus is the translation of the Hebrew name Daniel, and
Theocritus is also the Greek poet most admired, studied, and emulated by
the young Heinsius; the designation "à Ganda" (from Gent) clearly refers
to Heinsius's birthplace which the poet likewise fondly commemorated with
the Latin epithet "Gandivus" or "Gandensis."

 This first collection of love emblems went through several edi-
tions; in ca. 1607 it appeared under the title *Emblemata amatoria: iam
demum emendata* ("Love Emblems: Now still enlarged"), after which date
Emblemata amatoria became the title commonly used for Heinsius's love
emblems. The "enlargement" in 1607 merely consisted of the addition of
two more Dutch love poems, while an entirely new series of twenty-four
emblems "Het ambacht van Cupido" ("The Trades of Cupid") was included in
the 1613 edition: *Afbeeldingen van Minne. Emblemata amatoria. Emblemes
d'amour. Op een nieu oversien ende verbetert door Theocritum a Ganda.*
The trilingual title (Dutch, Latin, French) of this "newly revised and
enlarged" edition corresponded to the Dutch epigrams by Heinsius, the
Latin distichs by Petrus Scriverius, and a French quatrain for each

emblem, indicating a printing for a wider audience in the Low Countries, in France, and in Germany.

Heinsius's success was continued by a series of distinguished emblem books from the Low Countries all exclusively devoted to the theme of love. During the later years of his life, Otto van Veen, one of the foremost painters and engravers of his time, a teacher of Rubens, turned to designing and publishing illustrated books. After the immensely successful *Emblemata Horatiana* of 1607 he brought out the *Amorum emblemata* (1608) simultaneously in four polyglot versions--Latin paired with any two of the following languages: Dutch, French, English, or Spanish--in Antwerp, acting as his own publisher. In 124 emblems which Vaenius himself designed, Cupid functions as an allegorical representation of love; van Veen, who was born in Leiden and who, in spite of the religious and political differences between the United Provinces and the Spanish Netherlands, kept close contact with the cultural developments in the North, used several of Heinsius's pictorial concepts while Heinsius in 1613 then incorporated some of van Veen's.

In 1611 P. C. Hooft published his first volume of love poetry entitled *Emblemata amatoria,* which is prefaced by a series of thirty emblems with mottoes and couplets in each of the three languages, Latin, Dutch, and French. Like Heinsius's collection, it is introduced by a Dutch poem, "A Preface to Youth," the emblem series is framed by an allegorical representation of Venus, and Cupid demonstrates the ways of love in most emblems.

The close association of emblematic pictures with lyric poetry is evident in such volumes as W. I. Stam's *Cupido's Lusthof* ("Cupid's Pleasure-Ground") of 1613, where love poems and songs are interspersed with love emblems. And while already in 1615 Otto van Veen had endowed love emblems with religious meanings in his *Amoris divini emblemata,* the publication of Heinsius's *Nederduytsche Poemata* shortly thereafter, which included both series of love emblems, made these available to a wide-reading public, especially also in Germany. Crispijn de Passe the Elder, in whose workshop the plates for this edition had been produced, published a rival collection of love poetry including emblems, the *Thronus Cupidinis,* in 1616.[7] Besides containing poems by Bredero, Vondel, Roemer Visscher, Heinsius, and Ronsard, several emblems were derived from van Veen and some plates made for the *Nederduytsche Poemata* of 1616 were used also for the *Thronus*.

The last major original collection of love emblems was Jacob Cats's *Silenus Alcibiadis, sive Proteus* (1618), who introduced realism,

contemporary scenes, and didacticism. The fifty-one love emblems in
Part I were used again with moral explanations in Part II, finally
receiving religious interpretations in Part III. Cats freely used
ideas and representations from his predecessors, but the homely, moral-
izing explanations in Latin, French, and Dutch which centred on man as
a member of his family and society set a popular trend for subsequent
emblem books. Later collections such as Raphael Custos, *Emblemata
amoris* (Augsburg, 1622), J. H. Krul, *Minne-Spiegel ter Deughden* (Amster-
dam, 1639), Philip Ayres, *Emblemata amatoria* (London, 1683), or the
Emblematoria/Emblemes d'Amour en Quatre Langue ([London; i.e. Amsterdam]
ca. 1690) simply copied earlier emblems.

 Before we proceed to the descriptive analysis of individual em-
blems, we need to look at how others have studied and approached the con-
tents of this specialized group of emblem books. For the first collec-
tion of Heinsius and that of Vaenius, Praz searched for earlier sources
of the conceits used therein, focussing mainly on the "Petrarchist" tra-
dition, a major area of research in Romance lyrical poetry,[8] which
H. Pyritz had applied to the poetry of the German Baroque poet Paul
Fleming.[9] Literary antecedents are established under the assumption of
influences and borrowings from this tradition, a method derived from
positivistic literary scholarship and from iconology, which can, and of-
ten does, provide extremely useful information, but which also tends to
disregard the complexity of the individual emblem and the diversity of
the different emblems, and to slight the pictorial elements. Here tra-
dition is emphasized at the expense of the totality of the emblem. An
unpublished Louvain thesis of 1975[10] incorporates Praz's findings and
categorizes the love emblems along conceptual lines by grouping them
according to their meanings, such as "I. Properties of Love (pp. 34-80):
1. Satisfaction; 2. Love as a) source of great deeds, b) of eloquence,
c) of art, d) of a second nature, e) of virtue; 3. Unity of Love;
4. Eternity of Love; 5. Renewal of Love; 6. Hope; 7. Idealisation;
8. Power; 9. Life-giving quality; 10. Disclosure of Love; 11. Perfec-
tion . . ." and so on. Each emblem is then outlined by giving the motto
(with its Dutch equivalent), a very brief description of the main pic-
torial motif, a rendering of the Dutch subscription and Latin text, and
a reference to possible sources as given in Praz, for the most part. A
picture-index (alphabetical by main motif only) and an alphabetical
listing of the mottoes by languages complements the descriptive part.
The fuzzy and useless categorization of meaning totally disregards, it
seems to me, the interrelationship of pictorial and verbal qualities of

the emblem. In our context, it also points to the difficulty of index-
ing emblems in regard to meaning when abstract qualities, moral sugges-
tions, and modes of behaviour are involved, rather than definable con-
cepts. The unsophisticated summation of content uniformly applied to
each emblem does not allow for the individual differences and qualities
of the often varied emblems. A superficial assessment results, not an
analytical description.

The most widely known classification of emblems is, of course,
the *Emblemata Handbuch* of Henkel and Schöne. However, Mario Praz aptly
assessed its value, saying that it is "limited to a comparatively small
number of emblem books . . . therefore it is disappointing as a consul-
tation work, and has rather the nature of an anthology."[11] This state-
ment certainly holds true for the *Emblemata amatoria*, although the major
series are represented in it much more adequately than are other groups.
For Heinsius Henkel/Schöne chose a late edition of 1615 (some numbering
and pictorial content differs from earlier editions) with 7 out of 48
emblems reproduced (20 additional ones used for cross-references).
Vaenius is amply represented with 40 out of 124 (11 cross-referenced).
Seven out of 30 by Hooft are included (5 more with cross references);
the *Thronus Cupidinis* in its third edition of 1620 was used 7 times for
cross-references, and all of Cats were included (36 complete, 18 as
cross-references) from a revised edition--the revisions largely textual
--of 1627.[12] Problems regarding the summation of meaning and the exclu-
sion of certain emblem groups will be referred to later in the discus-
sion of specific authors and emblems.

As to the availability of these books of love emblems, we are
in a much better position than with most others, since reprints have
appeared in recent years. Heinsius's *Quaeris quid sit amor* was reprinted
in its third edition, *Emblemata amatoria* (ca. 1607), in 1973 by the now
defunct Scolar Press (Continental Emblem Books No. 10); both series will
be available again shortly in my facsimile-edition of the *Nederduytsche
Poemata* (Nachdrucke Deutscher Literatur des 17. Jahrhunderts No. 32).
Vaenius was reprinted by Olms (Hildesheim) in 1970 (Emblematisches Cabi-
net No. 2),[13] Hooft in a limited and very expensive special edition of
his published works in 1971,[14] while the critical commentary prepared by
P. C. Tuynman is still held up by financial and editorial complications
and it may take years before the notes on the *Emblemata amatoria* will ap-
pear there. The third edition of the *Thronus Cupidinis* was reprinted in
1968 in a collector's edition for the Amsterdam University Library by
H. de la Fontaine Verwey. Cats's *Silenus Alcibiadis*, in spite of the

author's long-lasting popularity as the Dutch household poet, was repro-
duced in selections only, though repeatedly during the nineteenth and
this century,[15] while the original first edition is a rare item, even in
Dutch libraries. This is also the case with several later series (e.g.,
the *Théâtre d'amour*); thanks to the bibliographies by A. G. C. de Vries[16]
and John Landwehr,[17] these have been recorded, though there are very
few copies, some located in private collections in the Netherlands
rather than in public libraries. Accessibility as well as *precise* bib-
liographical information are, of course, essential for any indexing and
for the prospective user of an index.

An analysis of typical emblems from each series applying the
classifications suggested by Peter Daly will test the feasibility of his
indexing model and point to problem areas. I shall analyze sample em-
blems without regard to antecedents which, when the Index has been real-
ized, will become self-evident. My question with each emblem thus asks
"what is conveyed in *pictura* and *scriptio*" and not "where did the author
get it from."

1 *Heinsius*

In regard to his *Quaeris quid sit amor,* we know that the *pic-
turae* were designed several years *before* any texts were added to the em-
blem. As Petrus Scriverius informs us in the *Nederduytsche Poemata*
(1616), a certain "liefhebber" (amateur or lover) had selected twenty-
four emblems from the collections of the famous Dutch physician
Hadrianus Junius and others, and had engravings made from them for which
Daniel Heinsius only later supplied the needed Dutch verses. The artist
has been identified as the well-known engraver Jacques de Gheyn who
lived in Leiden for several years after 1596 and came into close contact
with the university and Dousa's circle. In this series we have more
often than not a complex design of high artistic quality--the refined
technique of copper engraving permitted more delineatory and pictorial
detail than can be found in the comparatively crude and sketchy wood-
cuts--and three types of verbal complements: (1) a motto (in French,
Latin, Dutch, or Italian) at the lower edge of the circular emblem;
(2) a Latin distich engraved around the circular frame of the emblem;
(3) an eight-line Dutch epigram headed by the motto. French quatrains
were added for the editions from 1613 to 1615. Since the verbal com-
plements were written by two, sometimes three, different authors, they
are not always identical; however, in this series the motto is the most
important component for the meaning of the entire emblem.

Certain emblems in this series are easily classified in regard to their major motif. The salamander in the fire (No. 6) with the motto "A autruy mort, a moy vie" ("Death for others, life for me") readily fits the proposed categories (see Illustration 15).

Illustration 15 [Daniel Heinsius], *Quaeris quid sit amor?* (1601), No. 6.

1. Motif: Salamander in fire.
2. Meaning: Love thrives through heat (passion).
3. Description of subject: Winged reptile sitting in and eating flames.
4. Description of setting: Rocky mountain ledge.

Since an easily identifiable subject is shown in a specific situation, indexing is no problem. Yet in most emblems in this series Cupid, as a personification of love, as well as humans are depicted in some sort of interrelated action. Lest we come up with an interminable number of Cupids only--and the alphabetical index should, of course, list all those Cupids--other motifs (usually two or three) must be recorded as well, usually (1) a figure, (2) an action or situation, (3) the object, circumstance, or tool of this action.

 For example, in No. 9, "Ni spirat immota" ("without wind, there is no motion"), the *pictura* shows Cupid shooting arrows at an idle wind-

mill, with a man leaning on the fence, a woman walking away (see Illustration 16).

Illustration 16 [Daniel Heinsius], *Quaeris quid sit amor?* (1601), No. 9.

1. Motif: Windmill, idled.

2. Meaning: No life without the beloved.

3. Description of the subject: Cupid pointing arrow at idled windmill, man leaning on fence, woman walking away.

4. Description of setting: Meadow with trees on the left, village in the backgrounds, clouds.

Cupid functions in the *pictura* as a sign indicating that this emblem is to be read as a depiction of love; Cupid's pointing to the windmill designates this as the major motif of the *pictura*. Both the Latin couplet and the Dutch epigram elaborate the simile, which is contained in a nutshell in the motto and illustrated in the *pictura*: Just as the wind moves a windmill, the beloved animates the lover. There is still another fine semantic distinction: In the couplet the beloved's grace (*gratia*) is required to restore the mutilated (*truncus*) lover's wholeness; in the epigram the beloved's breath (*haeren adem*) from her very mouth is the life-giving force--the metaphor staying closer to the motif in the *pictura*. Here then the question arises where to draw the line of cate-

Illustration 17 [Daniel Heinsuis], *Quaeris quid sit amor?* (1601),
No. 3.

sets of plates were cut in imitation of the original emblem by De Gheyn
(oval plates for the 1613 edition by an anonymous artist; small rectan-
gular ones for the *Nederduytsche Poemata* of 1616 by the Crispijn de Passe
workshop; and again small rectangular ones for the pirated (?) edition of
this work by van Westerhuysen in 1621), which copy the main emblematic
motif faithfully, but simplify the setting (e.g., the couple is lacking
in the rectangular plates). Realistic, elaborate settings are a major
characteristic of Dutch love emblems, as we shall see especially with
Hooft, and indexing these settings would, in my opinion, overburden the
IE with extraneous detail.

In Heinsius's second series, "Het ambacht van Cupido" ("The
trades of Cupid"), which originated in 1613, Cupid is shown in some
activity (mostly handicrafts or games); e.g., in No. 21 "Bulla favor"
("Affection is a bubble"), Cupid is shown blowing soap bubbles (see
Illustration 18).

 1. Motif: Bubble

 2. Meaning: Affection perishes quickly

21. *Bulla favor.*

Illustration 18 Daniel Heinsius, *Nederduytsche Poemata* (Amsterdam, 1616), No. 21.

3. Description of subject: Cupid blowing soap bubbles
4. Description of setting: Dutch landscape with trees, water, a boat; village in background.

Henkel/Schöne summarized the meaning as "Unbeständige Liebe" (col. 1316; "inconstant love"). This, as well as my narrative summary which is based on the picture rather than on the Henkel/Schöne rendering of the motto, would be lost in the alphabetical Index unless a comprehensive index of meanings based on the emblem as a whole were to be established.

Another problem arises from the setting; how much meaning is to be ascribed to the boat coming ashore, which in the iconographical tradition can mean death, and to the church steeple connoting perhaps eternal life? The epigram does not hint at a framework of ideas; rather, the ideas that "Cupid is playing a game" and that favour is but a perishable commodity are playfully presented. The anonymous engraver of the original series of 1613 merely placed Cupid in a room when transforming the vanity-motif "homo bulla" ("man is a bubble")[18] into a love emblem, while the artist of our *pictura* who belongs to the Crispijn de Passe workshop added the realistic landscape. But did he intend for the boat and the church to signify death and eternal life, or did he simply want to complement the Cupid figure with a detailed background for aesthetic reasons? I think the latter is the case with this emblem, though the question will have to be asked again in each instance, and, in the case of Hooft, it may be answered differently.

2 *Vaenius*

The 124 emblems in the *Amorum emblemata* (1608) of Otto Vaenius are varied and complex, because Vaenius was a major allegorical painter who made extensive use of the iconographic tradition, and because the

4. Description of setting: Fountain with cornucopia at right;
 landscape with river, trees on embankment, bridge, tower,
 hills and village.

The attributes of Fortune dominate this *pictura*: the blindfold, the
sail and rudder (indicating her control over the sea), the ball, the
cornucopia. It is a literal rendering of the quotation from Cicero:
"Not only Fortuna herself is blind: but usually she also blinds those
whom she has embraced: likewise men disregard old loves and indulge in
new ones." Vaenius's *pictura* is usually based on the Latin epigram (or
prose quotation) which appears in each of the polyglot editions, while
the meaning evolves from the motto.

Problems in classifying motifs arise when these do not appear in
the *pictura*. In "Post nubila Phoebus" ("after the clouds the sun"),
Cupid sits in the foreground at a sea-cliff pointing towards the sky in
which two winds are shown blowing at a stormy sea where a large rock
sits unperturbed (see Illustration 21). Here the major motifs are sea,
stormy *and* rock; Cupid is merely a sign indicating that the emblem be
read as a representation of a specific situation of love. The sun men-
tioned in the motto does not appear in the *pictura*; thus it would be
dropped from our classifications. And how is the meaning indexed?
"Quiet after a storm" remains a metaphorical level, but "change for the
better" or "good times follow bad ones" remain so unspecific that it is
lost in an alphabetical index. It is this type of emblem, numerous in
Vaenius, which Henkel/Schöne left out because it would not fit the
Idealtypus. Is such a representation of a sequence of events, which I
will call "narrative," still an emblem? And while this is, of course,
a moot question as far as Vaenius was concerned, it is the "narrative"
nature of many of his *drawings* which cause problems in indexing.

Vaenius's settings are highly varied and will be difficult to
classify. If we were to index these settings, we would end up with in-
numerable rocks, flowers, houses, villages, castles, brooks, mountains,
clouds, etc. Except for some instances, as, for example, the ocean, winds,
clouds, and rocks in the previous example, the settings are merely deco-
rative and complementary; they do not carry a significance. It becomes
obvious that with Vaenius (as in Heinsius and Hooft) realistic background
belongs to the emblem for artistic and aesthetic reasons, but it is usu-
ally not endowed with conceptual qualities. Thus indexing these settings
or motifs therefrom seems to be pointless to me, *unless* they can be
shown to reflect actual cities, customs, tools, clothing, etc.

Illustration 21 Otto Vaenius, *Amorum emblemata* (Antwerp, 1608), p. 143.

3 *Hooft*

P. C. Hooft, a major lyric poet of the seventeenth century, prefaced his first published collection of poetry with emblems of extraordinary artistic quality. Whether they were designed by the eminent engraver Crispijn le Blon or by P. Serwouter (the title was signed by him) has not been ascertained. In the *Emblemata amatoria* (1611) we have thirty very complex emblematic pictures which are pictorial manifestations of the verbal conceits in the trilingual two-line epigrams. Peter Daly has already pointed to the "combination of foreground cluster and background scenes as a compositional principle" and derived from this the necessity to index secondary motifs as well. Mottoes in three languages frame the large rectangular engraved emblem, as in No. 10: "In lyden blinck ick" ("in distress I gleam"), "Si feriar fulgeo ("when hit I sparkle"), "Des tenebres la lumiere, et de la mort la vie ("after darkness, light and after death, life") (see Illustration 22).

1. Motif: Cupid, striking fire
2. Meaning: Love thrives through distress

[sic] ont fallys en amour" ("those who have succumbed through love").
These two sections, which also have verses in Latin and French, contain
mythological episodes, the illustrations being partially based on Bernard
Salomon's plates for Gabriel Simeoni's *Metamorphose d'Ovide figurée*
(Lyon, 1557). Thus it becomes clear that there was no sharp distinction
for the artists involved (the designer as well as the author of texts)
between emblems and illustrated poems. Narrative, often mythological
episodes became an integral part of emblem books, a fact to which already
the subsequent editions of Alciatus can attest.

The *Thronus Cupidinis* also is a good example for the adaptation
and modification of illustrations and content occurring in subsequent
editions. The second edition of the work was brought out already in
1618 by the rival printer Willem Jansz (whose edition of Heinsius had
been plagiarized in the first place). Jansz distributed the material
over two different books, the first volume containing Vaenius's emblems
entitled *Othonis Vaeni emblemata aliquot selectiora amatoria* (seventy
emblems including twenty-three from *Thronus* I with new plates) and a
second volume containing, roughly speaking, the remainder, with the
title *Thronus Cupidinis*. While in this new *Thronus* sections II and
III remained unchanged, the first section, "Emblemata amatoria," was
reduced to thirty-two emblems (still containing four derived from
Vaenius). The illustrations are mostly free copies, in reverse, from
Crispijn de Passe's original *Thronus*. But even more importantly, Dutch
quatrains by no less a poet than G. A. Bredero were added to each em-
blem. Such a complicated printing history, which of course is charac-
teristic of every successful emblem book (to say nothing of Alciatus),
points to the necessity for correct bibliographical information and
comparison of editions *before* any indexing can be done.

5 *Cats*

Our last example is taken from Cats's *Silenus Alcibiadis* (1618),
an immensely popular and influential collection, which likewise abounds
with narrative, mythological, and moralistic elements often difficult
to classify. This first major emblem book by Cats presents problems,
because numerous texts (usually five) in three languages (Latin, Dutch,
French) accompany each emblem, because each emblem receives three dif-
ferent interpretations, and because some numbering and texts were
changed in subsequent editions. The modified 1621 edition was used by
Henkel/Schöne, because the German translations by RaeBfeldt (1710) were
based on this edition. My example is taken from the Part I of the first

Plutarch, in Moralib.

Illustration 24 Jacob Cats, *Silenus Alcibiadis, sive Proteus*
 (Middleburg, 1618), No. 26.

edition (see Illustration 24). Rather than classifying it, I shall dis-
cuss this *pictura* with its texts in the 1618 edition only. The large,
round, unframed picture shows a mask being proffered by a hand from the
clouds, on the left three boys fleeing in fear, on the right three boys
unafraid pointing towards the other group, tools of three games (three
bones, two tops and a whip, two burrins [?]) are abandoned on the ground,
to the left is the wall of a house (does the vegetation on its upper
corner indicate a decaying building?), a landscape with mountains, a
village, a river complete with a footbridge, a boat and people, a for-
mation of birds are in the air. The motif is a mask with children play-
ing games. The meaning depends on the part of the book in which the
emblem appears. In Part I the motto "Inverte, et avertes" ("turn it
around, and you'll turn it away") is expanded by the texts on the fac-
ing page which advise the lovers to look behind the mask in order to
overcome any fear of loving. Actually, the idea for this emblem is
based on the simile from Plutarch, its moral stated in the quotation

Warburg school and lists, alphabetically, descriptions of persons (per-sonifications), titles of pictures (major ones only), and objects. It is a valuable instrument for reading pictorial detail in emblems. The *Dictionary of Symbols and Imagery* (1974)[23] lists the major symbols (no distinctions are made between symbol, allegory, metaphor, etc.) from "Western civilization." Both dictionaries almost completely disregard emblems and must be supplemented by a dictionary of emblems or a theme and motif index to emblem books. There is a growing interest among lit-erary and art historians in the iconology as is also attested by the new series "The Philosophy of Images" (Garland Publishing) which will reproduce twenty-two iconographic texts. But neither these nor other facsimile editions of emblem books are yet a step in the direction of an Index Emblematicus.

NOTES

[1]Leonard Forster, *The Icy Fire. Five Studies in European Petrarchism* (Cambridge, 1969), p. 191.

[2]Ernst Bäumler, *Amors vergifteter Pfeil. Kulturgeschichte einer verschwiegenen Krankheit* (Cologne, 1977).

[3]*Studies in Seventeenth-Century Imagery* (Rome, 1964), 2nd ed., pp. 83-134.

[4]"*Quaeris quid sit amor?* Ascription, Date of Publication and Printer of the Earliest Emblem Book to be Written and Published in Dutch," *Quaerendo*, 3 (1973), 281-90.

[5]"Notes on the début of Daniel Heinsius as a Dutch Poet," *Quaerendo*, 3 (1973), 291-308.

[6]*Inleiding tot de Nederlandse emblemataliteratuur* (Groningen: Wolters-Noordhoff, 1978).

[7]The complicated printing history of this series has now been analyzed by Herman de la Fontaine Verwey, "The *Thronus Cupidinis*," *Quaerendo*, 8 (1978), 29-44.

[8]See J. Vianey, *Le Pétrarquisme en France au XVIe Siècle* (Montpellier, 1909); A. Meozzi, *Il petrarchismo europeo* (Pisa, 1934); Luigi Baldacci, *Il petrarchismo italiano nel cinquecento* (Milan, 1957); J. G. Fucilia, *Estudios sobre el Petrarchismo en España* (Madrid, 1960).

[9]*Paul Flemings Liebeslyrik* (Göttingen, 1963). Palaestra 234; Gerhart Hoffmeister, *Petrarkistische Lyrik* (Stuttgart, 1973). Sammlung Metzler 119.

[10]André Janssens, "De Nederlandse liefdesemblematiek van 1607 tot 1618."

[11]*Studies in Seventeenth-Century Imagery.* Pt. II: *Addenda et Corrigenda* (Rome, 1974), p. 11.

[12]Already in the second edition of 1618, the emblem pictures are printed only once for Part I, while Parts II and III contain explanatory texts only, with significant additions in Latin and Dutch. After numerous editions in subsequent years (Landwehr, *Dutch Emblem Books*, no. 81-91), the 1627 edition--Landwehr considers it a new book altogether-- has new plates, the pictures being reversed and framed, and the Dutch epigrams have been revised.

[13]Another reprint of Vaenius's *Amorum emblemata* (1608), an edition including English versions of the text, has been announced for 1979 by Garland Publishing Co., as no. 9 in the series "The Philosophy of Images" edited by Stephen Orgel.

THE EMBLEMS OF HENRY PEACHAM: IMPLICATIONS FOR THE INDEX EMBLEMATICUS

Alan R. Young

In her study of *English Emblem Books* Rosemary Freeman remarked that whereas for most emblem writers the fashion for emblems "provided a casual occupation, for [Henry] Peacham it was almost a profession."[1] Peacham was indeed involved in emblem writing throughout a literary career that lasted from 1603 to about 1644, but by profession he was actually a teacher. The rigours of this job did not, however, cut him off from the culture of his day, as is clear from his many and varied writings. These include two important treatises on the graphic arts, two lively collections of epigrams, essays, and pamphlets on a wide variety of topics, and the best-known work of courtesy literature of the period, *The Compleat Gentleman*. To these must be added his *Minerva Britanna* (1612), the most important English emblem book that had yet appeared.

When reading through Peacham's works, one finds oneself in contact with a mind that can move freely among a multitude of studies: cosmography, mathematics, history, painting, music, sculpture, fishing, heraldry, antiquities, and poetry. Indeed the Renaissance ideal of wholeness defined in *The Compleat Gentleman* is mirrored in Peacham himself, who, in addition to his teaching, engaged at different times in drawing and painting, social and political criticism, heraldry, the writing of poetry, wartime reporting, and musical composition. My reason for stressing the range of Peacham's interests and accomplishments is to show how suited his talents were to emblem writing, and here I would like to single out two of the most relevant of these talents. Firstly, he was an accomplished master of the epigram, that form of poetry most suited to the emblem form, and it should be noted that in addition to composing the poetry for his Latin and English emblem books he published two collections of epigrams in 1608 and 1620.[2]

Secondly, Peacham appears from an early age to have dabbled in the graphic arts with some degree of accomplishment. In *The Compleat Gentleman* he states:

> Painting is a quality I loue (I confesse) and admire in others,
> because euer naturally from a child, I haue beene addicted to
> the practise hereof; yet when I was young, I haue beene cruelly
> beaten by ill and ignorant schoolemasters, when I haue beene

83

> taking, in white and blacke, the countenance of some one or other
> (which I could do at thirteene and fourteene yeares of age [. . .]
> yet could they neuer beate it out of me.[3]

While a student at Cambridge, Peacham drew a "mappe" of the town, but
this, along with the frequent portraits from the life he later claims
to have done of King James,[4] have not survived. However, an early draw-
ing dated 1595 has,[5] one of the most important pieces of visual evidence
regarding the production of an Elizabethan play--in this instance
Shakespeare's *Titus Andronicus*.

Peacham was thus a skilled practitioner in epigrammatic poetry
and in drawing, the two most essential arts of the emblem writer. Yet
if Peacham possessed the necessary talents and interests for emblem
writing, the prospects for the would-be English emblem writer who wanted
to go into print were not good at the beginning of the seventeenth cen-
tury. In spite of the popularity and widespread production of printed
emblem collections in Italy, France, Germany, Spain, and the Low Coun-
tries, there was no comparable flow of emblem books from English print-
ers' presses, even though the continental books were admired, owned, and
alluded to by many Englishmen.[6] Prior to Peacham's *Minerva Britanna* of
1612 there were arguably only four printed emblem collections produced
by English writers, though the English translation of Van der Noot's
A Theatre for Worldlings (1569) has some claim to be considered as a
fifth. First was Geffrey Whitney's *A Choice of Emblemes* (1586), but
this was printed by Christopher Plantin in Leyden. Of its 248 emblems,
202 used woodcuts taken from the blocks prepared and already used by
Plantin in the emblem books of other authors. Two other English works
prior to *Minerva Britanna* were translations: P.S.'s *The Heroicall
Devises of M. Claudius Paradin* (1591) and Thomas Combe's version of de
la Perrière's *The Theatre of Fine Devices* published ca. 1593; 1st extant
ed., 1614). Finally, there was Andrew Willet's *Sacrorum Emblematum
Centuria Una* (1591-92), which, although it was the first example of an
English author's conscious attempt at independence from continental
material, nonetheless consisted of "naked emblemes," or emblems without
pictures. Significantly two English editions of impresas of this period
--Samuel Daniel's translation of Giovio entitled *The Worthy Tract of
Paulus Iovius* (1585) and Abraham Fraunce's *Insignium, Armorum, Emblema-
tum, Hieroglyphicorum, et Symbolorum* (1588)--also contain no illustra-
tions.

The comparative sparsity of English emblem books is almost cer-
tainly due to the state of the English book production industry. Some

woodcut illustrations and even copper engravings are to be found in
English books throughout the sixteenth century, but there was never any-
thing like the numbers of highly skilled illustrators who supplied book
and print sellers with material on the Continent, as Peacham himself
mentions when he states in *The Art of Drawing* (1606) that "scarce
England can affoord vs a perfect penman or good cutter."[7] Although some
continental craftsmen did take up residence in England or worked there
for a period, their presence did not substantially alleviate the short-
age of English illustrated books in the early decades of the seventeenth
century. English printers could of course import woodblocks and copper-
plates, as they regularly did type and paper, but they had to consider
the extra costs involved in paying the block or plate-maker, in having
to print engravings as a separate entity, and in purchasing products
from abroad which might have only a limited use. While many printers
imported type ornaments and decorated initial letters that could be used
again and again, emblematic illustrations were obviously a very differ-
ent matter. The solution for the English emblem writer was either to
get his work published abroad, as Whitney did, perhaps using blocks that
were already in a printer's stock, or to publish in England and omit
illustrations, as Willet did.

One of the remarkable achievements of Henry Peacham is that he
appears to have solved this problem by designing and probably also pre-
paring his own woodblocks.[8] It is unlikely that he got much reward for
what must have been an enormous labour, but he doubtless had the satis-
faction of knowing in 1612 that *Minerva Britanna,* as far as the English
book trade was concerned, was unique, since it was the first completely
original illustrated emblem book by an English author, and the first,
one might add, to use English devices and literary works as sources for
the pictures and poems of some of its emblems.[9] Consequently it is not
surprising that Peacham began his book on a note of self-congratulation:

> I haue heere (kind Reader) sent abroad vnto thy view, this volume
> of *Emblemes,* whether for greatnes of the chardge, or that the Inven-
> tion is not ordinarie: a Subiect very rare. For except the col-
> lections of Master *Whitney,* and the translations of some one or two
> else beside, I know not an *Englishman* in our age, that hath pub-
> lished any worke of this kind. [10]

Peacham's emblem writing, however, did not begin with *Minerva
Britanna,* nor did it finish there. In 1603 when the new King James
journeyed south to London from Edinburgh, Peacham presented him with one
or two of his emblems,[11] and it was soon after this that Peacham con-
ceived the idea of turning into emblems James's newly published

Basilicon Doron,[12] that manual of kingly and paternal advice written for
James's first son, Prince Henry. Peacham's method was to select key
statements from James's work and use them as the foundation for a series
of fifty-six pen-and-ink emblems. He dedicated this collection to
Prince Henry, but the manuscript, now in the Bodleian Library, Oxford,
was neither finished nor presented to the Prince.[13] Shortly after
October, 1604, Peacham completed another version of his *Basilicon Doron*
project, this time dedicated to the King himself. Again the manuscript,
now in the British Library,[14] was not presented to its dedicatee. We
do know that Peacham eventually did present some other emblematical ver-
sion of the *Basilicon Doron* to James,[15] but this finished copy is not
now extant.

Somewhat later in 1610 he presented Prince Henry with a manu-
script emblem book, yet another version of his *Basilicon Doron* formula,
now expanded to seventy-eight emblems for which Peacham supplied water-
colour pictures. This work is now in the British Library.[16] *Minerva
Britanna,* Peacham's only printed emblem collection, followed shortly
after with its dedication to the Prince and its expression of gratitude
to Henry for his "gratious favour" and "Princely and Generous inclina-
tion" (sig. A2[r]). In it Peacham abandoned the use of Latin verses in
favour of English poems and employed a mixture of emblems drawn from
his earlier collections, emblems collected from other sources, and em-
blems he had newly composed. It is on a grand scale, consisting of 100
emblems in Part I and 104 in Part II. There are further emblems on the
title-page, its verso, and the title-page for Part II. The book is
prefaced by a dedication to Prince Henry; by the conventional address
"To the Reader" which develops into a short treatise on the art of the
emblem; by a panegyric poem in Latin addressed to the Prince; and by a
series of poems addressed to the author and his *Minerva* in Latin,
Italian, French, and English. Part II is prefaced by a poem entitled
"The Author to his Muse," and the book ends with a lengthy poem in the
last line of which Peacham promises a further collection of emblems.

The pages containing the emblems tend to be densely packed (see
Illustration 25). Immediately below the motto for many of the emblems
Peacham has added dedications, the bulk of which are to the great and
powerful, the remainder being largely to his "private friendes." On fif-
teen occasions Peacham includes below his dedications an anagram on the
name of the dedicatee. Nine of these he proudly signs as his own inven-
tion. That for Sir Edmund Ashfield ("I fledd vnashamed") is a fine ex-
ample (see Illustration 26), since it directly relates to the theme of

the emblem itself which is concerned with Ashfield's recent troubles
that had forced him to absent himself from his friends (p. 42). Simi-
larly the anagram on Johannes Doulandus (see Illustration 35), "Annos
ludendo hausi" ("I have used up years by playing"), harmonizes totally
with the subject-matter of the remainder of the emblem (p. 74).

33 *Labor viris convenit .*

T O the moſt Honorable Lord , the L : Dingwell .

Hugonis Capeti
Symbolum .

W HO thirſteth after Honor , and renowne ,
By valiant act , or laſting worke of wit :
In vaine he doth expect , her glorious crowne ,
Except by labor , he atcheiveth it ;

primus ſump-
ſiſe labes,
primus iter ſump-
ſiſſe pedes. Sil: 1.

And ſweatie brow , for never merit may ,
To drouſie ſloath , impart her living bay .

Ipſe manu ſua
pila gerés præce-
dit anheli militis
orapedes mōſtrat
tolerare labo-
rem, non iubet.
Lucan de Cato-
ne.

* *HAMILCARS* ſonne , hence ſhall thy glory liue ,
Who or'e the Alpes , didſt foremoſt lead the way ,
With Cæſars eeke , that would the onſet giue ,
* And firſt on foote , the deepeſt foor,ds aſſay :

Mundities mulie-
ribus laborem vi-
ris convenie .
Marius apud Sa
luſtium .

" Let Carpet Knightes , of Ladies favours boaſt ,
" The manly hart , brave Action loveth moſt .

Virgil AEneid : 2

Diſce puer virtutem ex me verum , j Laborem
Fortunam ex aliis : nunc te mea dextera bello
Defenſum dabit , et magna inter præmia ducet .

Ex

Illustration 25 Henry Peacham, *Minerva Britanna* (London, 1612),
p. 33.

To the right worſhipfull Sir Edmund Aſhfeild Knight . 42

Edmund Aſhfeild .
I fledd vnſhamed .

Anagramma Au-
thoris .

T HE clouded Sunne , that weſtward left our ſight ,
 And for a night , in *T H E T I S* lap had ſlept ,
Againe's return'd , with farre more glorious light ,
" To cheere the world , that for his abſence wept :
 His beames retaining , vncorrupt and pure ,
 Although he lay impriſon'd and obſcure .

Noctes rorulen-
tas volo.

* So , Sir , although the cloudes of troubles , had
A while conceald you , from your louing frendes ;
You doe appeare at length to make them glad ,
And ſo much higher ſtill your name aſcendes ,
 By how much Envie , ſeeketh to oppreſſe ,
 And dimme the ſplendor of your Worthines .

* Adverſus virtu-
tem hoc poſſunt
calamitates, et
damna ,et iniuriæ
quod adverſus So-
lem Nebula po-
teſt : Seneca l.
pilt : 113 .

H I. *Præmio*

Illustration 26 Henry Peacham, *Minerva Britanna* (London, 1612),
 p. 42.

The woodcuts below are supplied with elaborate borders, for
which there are eight different patterns. These recur at different
points throughout the book, since the woodblocks for the pictures were
made quite independently of the borders themselves. Below the pictures
are the twelve-line poems, and the page is often further filled out by
quotations and annotations in the margins and below the poems. The

physical problems for Walter Dight, the printer, in setting up such
elaborate pages must have been considerable.

Of the 207 emblems in *Minerva Britanna* sixty-two had already
appeared in Latin versions in one or more of the *Basilicon Doron* col-
lections. They reappear scattered in random order throughout the book,
often with the page reference to King James's *Basilicon Doron* retained
in the margin at the bottom of the page along with Peacham's original
Latin quatrain. In addition to the repetition of earlier material,
which itself often owes much to earlier emblematists and iconographers,
Peacham includes much new material for which analogues can also be found
in other emblem collections of the period. In the study of emblem lit-
terature it is, of course, notoriously difficult to be sure of precise
sources (as opposed to analogues), but on occasion in *Minerva Britanna,*
Peacham either names his sources or one can be reasonably certain of
their identification. Bridging both categories are a series of almost
twenty emblems that owe illustration, contents, or both to Cesare Ripa's
Iconologia which in its illustrated form had appeared in two editions
(Rome 1603, and Padua 1611) when Peacham completed *Minerva Britanna.*[17]

Peacham's emblem on "Ragione di stato" (p. 22), dedicated appro-
priately to one of the Privy Council, Sir Julius Caesar, is a typical
example of the use Peacham made of Ripa's *Iconologia* (see Illustrations
27 and 28). From Ripa Peacham took both title and illustration. This
latter he modified slightly, omitting the book of the law which lies on
the ground beside the right foot of Ripa's figure and omitting the de-
tail of having her left hand rest upon a lion's head, but adding a cer-
tain amount of background landscape. The central female figure in
breastplate and helmet, armed with a sword at her left side and clothed
in a garment decorated with ears and eyes, looks to her right where she
strikes off the heads of some poppies with a wand. Behind her with his
head to her left stands a lion. In the margin beside his poem Peacham
repeats one of the sources cited by Ripa, but adds four quotations not
in Ripa. His poem is in three stanzas rather than the normal two. The
first, in a rather awkward mixing of metaphors, refers to the "ATLAS-
burden" of office that is the responsibility of whoever "sits at sterne
of Common wealth, and state." For this there is no parallel in Ripa,
but the remaining two stanzas which interpret the illustration are for
the most part a paraphrase of passages in the *Iconologia.* The fact
that the figure is armed, so both authors explain, signifies the strength
of her resistance to all foes. The eyes and ears depicted on her tunic
signify the intelligence received that assists in dealing with enemies.

Ragione di stato. **22**

To the right Honourable Sir IVLIVS CAESAR, *Knight.*

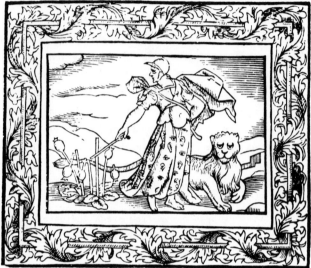

WHO sits at sterne of Common wealth, and state
 Of's chardge and office heere may take a view,
And see what daungers howerly must amate,
His ATLAS-burden, and what cares accrew
 At once, so that he had * enough to beare,
 Though HERCVLES, or BRIAREVS he were.

He must be strongly arm'd against his foes
Without, within, with hidden Patience :
Be seru'd with * eies, and listening cares of those,
Who from all partes can giue intelligence
 To gall his foe, or timely to prevent
 At home his malice, and intendiment.

That wand is signe of high Authoritie,
* The Poppie heads, that wisdome would betime,
* Cut of ranke weedes, by might, or pollicie,
As mought molest, or over-proudly clime :
 The Lion warnes, no thought to harbour base,
 The Booke, how lawes must giue his proiectes place.
 E 3. *His*

* Princeps sua
scientia non po-
test cuncta com-
plecti. Tacitus.
Annal : 3. Nec
vn us mentem
molis tantæ esse
capacem. An-
nal : 1.

* πολλοὶ βασι-
λέως ὀφθαλμοὶ
κ̃ πολλὰ ῶτα.
Xenophon. in
Pædia. Cyri.

* Rex velut deli-
berabundus in
hortum ædium
transit &c.
Livi : lib : primo
Decad : 1.

* Ne patiatur he-
bescere aciem
suæ authoritatis.
Tacitus
Annal : 1.

Illustration 27 Henry Peacham, *Minerva Britanna* (London, 1612),
 p. 22.

The wand represents authority, and her cutting off the tallest poppy-
heads shows the appropriate action due to upstarts. At the end of the
poem Peacham follows Ripa in his allusion to the book as signifying
"how lawes must giue his proiectes place," but oddly the book is not in
Peacham's illustration.

DI CESARE RIPA. 427

Leone, à piedi del quale fia vn libro poſpoſto da parte, con l'inſcrittione
IVS.

RAGIONE DI STATO.

Si dipinge armata, per dimoſtrare l'huomo che ſi ſerue di tal ragione,
vuole quando foſſero le forze il tutto dominare cõ l'arme, ò altro mezzo.

Si rappreſenta con la veſte di colore torchino conteſta d'occhi,e d'orec
chie, per ſignificare la geloſia, che tiene del ſuo dominio, che per tutto
vuol hauer occhi,& orecchie di ſpie, per poter meglio guidare i ſuoi diſe-
gni, & gl'altrui troncare.

Se gli dà la bacchetta per moſtrare queſta Ragione di ſtato eſſere pro-
pria di chi hà dominio, & ſignoria, dalla quale l'huomo diuiene imperio-
ſo, ancorche ogn'vno,per ben che Prencipe non ſia, poſſi hauere vna cer-
ta ragione di ſtato ia propria, con la quale vogli gouernare il dominio

Dd 4 delle

Illustration 28 Cesare Ripa, *Iconologia* (Rome, 1603), p. 427.

Other clearly identifiable sources for new emblems in *Minerva
Britanna* include emblems indebted to Paulo Giovio's *Dialogo dell'Imprese*
(first published 1555), to the title-page device for the 1595 and 1600
editions of Thomas Morley's *The first Book of Ballets to Five Voices*,
and to Whitney's *A Choice of Emblemes* (1586). Peacham's borrowings were
not, however, always from other emblematists. In a number of the,

Minerva Britanna emblems he uses the well-known impresas of such nota-
bles as Sir Philip Sidney, the Earl of Essex, King Stephen, and Erasmus.
Some of Peacham's other emblems had a more literary source. Freeman,
for example, has suggested that the emblem dealing with Pallas's entrap-
ment in a net by Avarice and a twofaced Dissimulation (p. 197) derives
from Spenser's *Masque of Cupid*.[18] The emblem of "A Shadie Wood" (p. 182)
is certainly indebted to Spenser.[19] Other emblems, of course, derive
from the emblematist's usual stock of proverbs, fables, commonplaces,
natural phenomena, and heraldry. In addition are the sources that
Peacham himself acknowledges, among them the Greek Anthology, Horace,
Ovid's *Metamorphoses*, Pliny's *Natural History*, and Aesop's *Fables*.
Some emblems, however, appear to be completely Peacham's creations.
These tend to occur where his picture and verse have been tailor-made to
suit a dedicatee or to suit some matter of personal concern to Peacham
himself. The emblems dedicated to Queen Anne, John Dowland, Christopher
and Mabel Collard, and Maurice of Hesse are of this kind, while the
rather contemplative composition expressing his concern for his future
and that expressing his love of music belong to the latter category (pp.
179, 204).

Some eight years after *Minerva Britanna* Peacham claimed that
following its publication he had renounced such poetic trifles and had
turned himself from such childish things to serious and useful matters.[20]
However, as he himself admits, he had at some stage during those eight
years been working on "a second volume of Emblemes, done into Latine
with their pictures."[21] There is no indication that Peacham ever pub-
lished such a work, but in about 1621-22 he did present a manuscript
emblem collection, entitled *Emblemata Varia*, to Sir Julius Caesar. This
is now in the Folger Shakespeare Library in Washington, D.C. In its
dedication Peacham again refers to his decision after *Minerva Britanna*
to give up such compositions as being trite and worthless but goes on to
explain that he decided to compose another collection on account of the
encouragement he had received from many good and learned men and on
account of his awareness of his special talents for this art form. The
result, though much briefer than any of Peacham's previous collections,
is a new and independent composition of twenty pen-and-ink emblems,
none of which bear any relationship to the three *Basilicon Doron* manu-
scripts or to *Minerva Britanna*.[22]

The emblems in *Emblemata Varia* owe nothing to Peacham's earlier
works and collectively differ in other ways. Whereas there is a steady
and successive increase in the number of personifications in the earlier

collections, the *Emblemata Varia* has almost none. There is a similar
lack of heraldic emblems. Absent too are the elaborate marginal annota-
tions and quotations from other authors which had made up a kind of
scholarly apparatus to accompany so many of the emblems in the *Basilicon
Doron* collections and in *Minerva Britanna*. By comparison, then, the
Emblemata Varia displays what for Peacham is unusual economy, something
matched by the brevity of the work.

In addition to the five extant emblem books so far described,
there also survive a number of Peacham's individual emblems: a comical
emblem depicting the shoes of the famous traveller Thomas Coryate for
Coryat's Crudities (1611), four heraldic emblems for Peacham's elegy
for Prince Henry, *The Period of Mourning* (1613), a prefatory emblem for
his eye-witness account of a military campaign in the Low Countries,
A True Relation (1615), and another for his essays, *The Valley of Vari-
etie* (1638), and finally several emblematic poems to accompany engrav-
ings by Wenceslaus Hollar, that brilliant engraver who was working in
England in the 1630s and 1640s and with whom Peacham collaborated on a
number of works.[23]

To conclude this brief survey of Peacham's achievement as an em-
blem writer, I should like to comment on two aspects of his technique.
The first concerns the organization of his emblem collections. An im-
portant feature of the *Basilicon Doron* manuscripts is that, like the
work upon which they are based, each is tripartite in structure. In his
prefatory Epistle to Prince Henry, King James had stated:

> I haue therfore [. . .] deuided this treatise in three partes. The
> first teacheth you your duty towards God as a Christian: the next
> your duty in your office as a king: and the third informeth you howe
> to behaue your selfe in indifferent things, which of them-selues are
> neither right nor wrong, but according as they are rightlie or wrong
> vsed; & yet will serue according to your behauiour therein, to aug-
> ment or empaire your fame and authority at the handes of your peo-
> ple. [24]

Thus in Book I of each of Peacham's manuscripts one finds admonitions to
love God, to have faith, and to read the Scriptures with a sanctified
heart. In Book II the emblems concern such subjects as a prince's duty
to teach his people by example, to avoid tyranny, to take care of the
oppressed, and to keep his laws brief and comprehensible, while in Book
III the emblems concern more general principles of behaviour such as the
need to avoid gluttony, to practise temperance, to ignore one's dreams,
and to be moderate in dress.

In this way Peacham is provided with an intrinsic unity and
organizational structure for his first three emblem collections and he

is consequently able to avoid the haphazard variety that is so typical
of such earlier emblem books as the 1531 edition of Alciatus, the 1565
edition of Hadrian Junius, the 1580 collection of Théodore de Bèze, or
the 1586 collection of Whitney. That the matter of form was of concern
to earlier emblem writers is evident, however, from the way in which
Alciatus's emblems were reordered in the 1549 edition and divided under
different moral headings,[25] and for similar reasons, it would appear,
Andrew Willet divided his emblems in *Sacrorum Emblematum Centuria Una*
(1591-92) into three classes roughly corresponding with Whitney's sug-
gested division of emblem literature into Historical, Natural, and Mo-
ral emblems.[26]

　　Curiously, in *Minerva Britanna* Peacham discarded the intrinsic
unity formerly provided by "the *Method*" of James's book, though to some
extent he compensated by developing the theme, emphasized by the title,
that the task of the poet is laborious and demanding, and that the art-
ist has a godlike status but is all too often neglected by those capable
of offering patronage. This theme is clearly related to Peacham's
own situation in 1611-1612 and represents a fairly direct plea for pa-
tronage to Prince Henry, the book's dedicatee, but as a theme it is in-
sufficiently sustained to offer an adequate structural equivalent for
the well-defined and effective three-part division of the earlier works,
and it does little to alter one's impression that *Minerva Britanna* is a
grab-bag for a wide variety of completely unrelated emblems. English
emblem literature was going to have to wait a little longer for the dis-
covery of the aesthetic advantages and complexities to be derived from a
sustained theme. As for Peacham's later *Emblemata Varia,* it has no ap-
parent organizational framework, nor do its twenty emblems have any
thematic relationship with one another.

　　My second point concerns the variety of Peacham's methodology.
If Peacham seems largely unconcerned with structural unity, he is equal-
ly unconcerned with unity of method, since he willingly mixes various
kinds of emblematic technique. These I would classify under five broad
headings--(1) personifications; (2) emblems of single symbolic objects
(these largely would include what Daly refers to as emblems with single
motifs); (3) diagrammatic emblems (these would include what Daly refers
to as emblems with motif groups and those with compounded motifs);
(4) narrative or anecdotal emblems (these would correspond to the em-
blems that Daly refers to as employing representational motifs); and
(5) heraldic emblems (a species of emblem that I am not sure Daly's pro-
posal fully accommodates, though in many instances such emblems could

be classed as emblems with single motifs). To conclude I should there-
fore like to discuss very briefly one example from *Minerva Britanna* of
each of these categories. At the same time I will comment upon prob-
lems concerning the indexing of certain kinds of information which I
feel is of sufficient value to be included in the Index Emblematicus,
in particular the matters of methodological classification (i.e., some
indication as to whether one is dealing with a personification or an
heraldic device), information about direct sources where these have been
established, and allusions to colour that may have vital symbolic sig-
nificance.

My first comments have to do with emblems presenting personifi-
cations. These make up a significant number of the emblems in *Minerva
Britanna*. Characteristically each is identified by a title which
replaces the function and position of the motto. Below is the picture
of a human figure symbolizing some human quality, and each figure is
usually accompanied by appropriate attributes. Examples would be
Philautia's mirror, the goat that accompanies Sanguis, or the bridle in
the hand of Temperance. Peacham's personification of the unstaid mind
(p. 149) holds bellows in one hand and a spur in the other to signify
that his mind changes with every passing influence (see Illustration
29). He is dressed "in sundry cullors light,/And painted plumes" adorn
his hat to further signify his variable and fantastic nature. As
Peacham's final line and his marginal note make clear, he has drawn
directly from Ripa's text and illustration of Capriccio (see Illustra-
tion 30). On the proposed index card, I should like to be able to
note this last fact, under "Source," since Peacham does identify his
source in the epigram and in the marginalia. Such information is of
importance and of considerable use to a good many potential users of
the Index, but it seems a pity that the current proposal cannot accom-
modate source information unless the source has been actually specified
by the author, as is the case with a number of Peacham's emblems derived
from Ripa without acknowledgement on the part of Peacham.

Though I see no difficulty in indexing "meaning" and "descrip-
tion of setting" for this emblem, I do see difficulty in defining the
actual "motif" entry. Does one merely say "Youth with bellows and
spur"? Surely one needs to be alerted to the fact that this is a per-
sonified figure, and it is the abstract quality personified that is
needed for proper identification of the motif. The Henkel/Schöne *Hand-
buch,* whatever its limitations, worked admirably in this area with re-
gard to personifications, whereas the Index, it seems to me, is poten-

149 *Levitas.*

A YOVTH arraid, in fundry cullors light,
 And painted plumes that overfpred his creft:
Defcribes the varieng and fantaftique wight,
(* For like our mindes, we commonly are dreft :)
 His right hand holdes, the bellowes to his eare,
 His left, the quick, and fpeedie fpurre doth beare.

Ecclefiaft :

Such is Capriccio, or th'vnftaied mind,
Whome thoufand fancies howerly doe poffeffe,
For riding poft, with every blaft of wind,
In nought hee's fteddie, faue vnftablenes :
 Mufitians, Painters, and Poetique crew,
 Accept what *R I P A*, dedicates to you.

Caf: Ripa peru.
gino.

Adhuc

Illustration 29 Henry Peacham, *Minerva Britanna* (London, 1612),
 p. 149.

tially less effective as a research tool. It would therefore appear
appropriate to recommend that the IE identify personifications by naming
them in the area reserved for motifs so that they are not lost to the
Index. Such a procedure would parallel the treatment of identifiable
Classical figures like Brutus proposed by Daly in his position paper.

DI CESARE RIPA,
C A P R I C C I O. 49

Si potrà anco veſtire con la veſte bianca, roſſa, & foſca dalla cinta in
ſu, & il reſtante del veſtimento farà negro, moſtrando, che la Luna non
ha lume da ſe, ma da altri lo riceue, & è d'auuertire, che per bellezza
di queſta figura ſieno eſſi colori poſti con gratia, i quali moſtrano, che la
Luna, ſpeſſo ſi muta di colore, & da eſſa molti indouinano le mutationi
de tempi. Onde Apuleo racconta, che la roſſezza nella Luna ſignifica
venti, il color foſco pioggia, & il lucido, e chiaro aere ſereno, & Plinio
nel lib.18.cap.31.dice il medeſimo.

Fu da gl'antichi depinta, che portaſſi a gl'homeri vna faretra, piena
di ſtrali, & con la deſtra mano vna facella acceſa, & con la ſiniſtra vn
arco.

 D Moſtra

Illustration 30 Cesare Ripa, Iconologia (Rome, 1603), p. 49.

Concerning colour something also has to be said. Perhaps the
colour symbolism could be incorporated into the description of the sub-
ject, but without specifying that his information comes from the text

and that the actual illustration is not coloured in the original (after all one of Peacham's emblem books was in fact coloured) are we not creating misleading ambiguities for future users of the Index? Certainly it can be argued that colour, like "bellows" or "bridle," is an identifiable attribute, something employed symbolically by the emblem writer. Colour could hence be considered as a motif and indexed as such so as not to be lost to the IE.

Peacham's emblem of the lily (p. 116) provides my example of the single symbolic object (see Illustration 31). This emblem had originally appeared in the *Basilicon Doron* manuscripts to accompany King James's advice to his son on the importance of practising moderation in dress, and the original Latin poem is here repeated at the foot of Peacham's page. The motto, "Salomone pulchrius" ("More beautiful than Solomon"), the marginal allusion to Matthew's gospel, and the poem itself refer us to the biblical injunction: "And why take ye thought for raiment? Consider the lilies of the field, how they grow; they toil not, neither do they spin: And yet I say unto you, that even Solomon in all his glory was not arrayed like one of these." Somehow I would like to see this clearly defined source acknowledged in the Index. Again, the Henkel/Schöne *Handbuch* classification system would have accommodated the information.

Once more colour is important. As Peacham recognizes in the poem, the lily, on account of its whiteness, is a traditional symbol of chastity and purity. With characteristic wit he contrasts in the poem the purity of the lily with the sexual mores of the celebrated Greek courtesan Rhodopis and the association of the lily with plainness of dress against her elaborate "silkes and sattens." Doubtless aware that Rhodopis means "rosy-cheeked," Peacham also achieves an implied contrast between the colours red and white, red being the symbolic colour of sexual desire.[27]

A third class of emblem that Peacham commonly uses is that in which the pictures portray the juxtaposition of several apparently disparate symbolic objects. Rosemary Freeman employs the term "diagrammatic" to denote those emblems "in which a number of different symbols are assembled together to represent a single idea. . . . In themselves, seen separately, the parts of a picture are wholly incongruous but clamped together by the idea to which they all contribute, they show only that limited aspect of themselves which will not conflict with the rest."[28] Such is Peacham's juxtapositioning of a closed book, a vertical unsheathed sword, and a serpent which encircles the blade of the

Salomone pulchrius. 116

L ET Courtly Dames, their coftly Iewells boaft,
 And *Rhodopis*, in filkes and fattens fhine;
Behold the *Lillie*, thus devoid of coft,
In flowery feildes, is clothd by power divine,
 In pureft white, fair'ft obiect of the eie,
 Religions weede, and badge of Chaftitie.

Why fhould ye then as flaues to loathed pride,
And frantique fooles, thinke ye are halfe vndone,
When that ye goe not in your cullors pide,
Or want the grace, of neweft fafhion:
 When even the *Lillie*, in glorie doth furpaffe,
 The rich, and roiallft King, that ever was..

Math: 6. 24.

Albedo obiectum
vifus. *Arift:*

 Splendida fluctivagos quid iactitat Aula lapillos?
 Intumet et Rhodopis bombycis arte levis?
 Regibus anteferor, mediis quod veftit in agris
 Vita oculi candor, virgincumque decus.

Soboles

Illustration 31 Henry Peacham, *Minerva Britanna* (London, 1612),
 p. 116.

sword in the second emblem in *Minerva Britanna* (see Illustration 32).
The motto "Sapientiae Initium" gives a hint of the central unifying
idea, but one requires the poem to understand the precise significance
of each individual object and the composite meaning that emerges from
their "diagrammatic" juxtaposition. The sword and the snake, Peacham
explains, signify the nature of Politeia, but he gives no further
details. For the full understanding of the whole he leaves it to us to

Initium Sapientiæ. **2**

A POYSONOVS Serpent wreathed vp around
 In ſcalie boughtes, a ſharpe two edged Sword,
Supported by a booke vpon the ground,
Is worldly wiſedome grounded on G O D S word,
 The which vnleſſe our proiects doth ſuſtaine,
 Our plot is nought, and beſt deviſes vaine.

What ever then thou hap to take in hand,
In formoſt place, the feare of G O D preferre,
* Elſe, like the Foole thou buildeſt on the ſand,
By this (the *Lesbian* * ſtone) thou canſt not erre,
 Which who ſo doth, his * firſt foundation lay.
 Contriues a worke that never ſhall decay.

Squammiger in gyros gladio ſe colligit anguis,
 Naturam ſignant quæ P O L I T I A tuam;
Effera Iuſtitia eſt, Prudentia vana S O L O N I S,
 Hæc niſi ſuſtentent Biblia ſacra D E I.

Timor igitur D E I ſolus eſt, qui cuſtodit hominum inter ſe ſocietatem, per quem vita ipſa ſuſtinetur, munitur, gubernatur. &c.

C I. *Cui*

* Firmamentum
eſt Dominus ti-
mentibus eum.
Pſalm : 24.

* Ariſtot : in E-
thicis.

* Conſiliorū gu-
bernaculum lex
divina ſit. Cypri-
an in Epiſtolis.

Baſili : Doron.
lib : 1. pag : 3.

Lactantius de Ira
divina. Cap : 1.

identify the vertical unsheathed sword as an attribute of Justice and
the serpent as an attribute of Wisdom. The poem gives prime importance
to the book which we are left to identify as the Bible, and in the il-
lustration the book is carefully made to provide a supporting base for
the sword and serpent, since knowledge of God is the foundation for
worldly wisdom. Peacham's picture, then, is a "diagrammatic" rendering

of Politeia and as such is typical of its kind. Not only does it as-
semble a group of seemingly unrelated symbolic objects to represent a
central idea, but the emblem as a whole can only be understood in the
light of the combined contents of its parts--motto, picture, and poem.

I see no difficulty in indexing this emblem in spite of its
complexities so long as it is agreed, as Daly suggests, that every use
is made of the text to identify precisely the visual motifs and their
composite meaning. Similarly I find no difficulty in dealing with
Peacham's emblem of Pallas and Ulysses (p. 69), which I would categorize
as belonging to that large group of emblems dealing with some narrative
incident from mythology, legend, history, or literature, or with some
commonplace or proverbial human activity. The motif of Pallas and
Ulysses is clearly recognizable from the picture (see Illustration 33),
but here, as in so many emblems of its type, what matters is not the
incident portrayed but its moral significance and instructive potential.
In this instance we need the text to explicate the lesson that wisdom
should always be our guide.

More interesting, perhaps, as a problem for the proposed Index
are Peacham's heraldic emblems, of which there are a significant number
in *Minerva Britanna*. As in the case of personifications and emblems
with biblical sources (to cite two of my previous examples), there are
clearly some advantages to grouping all heraldic emblems rather than
having them spread out under such motif headings as "shield," "two lions
with crown," "portcullis," "roses and thistles," "flag," or, as in the
illustration on page 45, "harp." As we infer from the motto of
Peacham's emblem, this harp (see Illustration 34) is the heraldic harp of
Ireland, and the emblem is concerned, as the poem makes clear, with the
disordered state of that land prior to the accession of King James, to
whom the emblem is dedicated. The central conceit of the emblem devel-
ops from the commonplace association of both harp (and one might add
lute) with order and harmony. Alciatus had employed the motif by pre-
senting a lute in connection with the political alliance and concord
that he hoped would attend a united Italy,[29] and Peacham some years
after *Minerva Britanna*, when commenting on the disturbed state of
England in 1639, was to use the motif again by explicating a complex
analogy between harmonious music and political concord and Orpheus with
his harp and King Charles I.[30]

Peacham, then, takes what is initially only a heraldic symbol,
the harp of Ireland, and he ingeniously provides an apt topical comment
on the relationship between England and Ireland through the addition of

Tutissima comes .

69

LO *Pallas* heere , with heedefull eie doth leade ;
 Vlisses in his travaile farre and neere :
That he aright , might in his Iourney treade ,
And shunne the traine of Error, every where :
 N' ought had *Vlisses* , ever brought to passe ,
 But this great Goddesse , his directresse was .

*Homeri Odyss :
lib :*

Though *Homer* did invent it long agoe ,
And we esteeme it as a fable vaine :
While heere we wander , it doth wisely show ,
With all our actions , *Wisedome* should remaine ;
 And where we goe , take *Pallas* still along
 To guide our feete , our eares , and lavish tongue .

*Wisedome is on-
ly the Princes
vertue . Arist: 3.
politic :*

Euripides.

Mens vna sapiens plures vincit manus.

*Valerius Flaccus
1 . Argonaut:*

---- Non solis viribus æquum
Credere, sæpe acri potior prudentia dextra.

In

Illustration 33 Henry Peacham, *Minerva Britanna* (London, 1612),
 p. 69.

the quite different iconographic connotations which the harp possesses.
Ireland, as the poem makes clear, once drenched in native blood on ac-
count of its civil disorder, here symbolized by the harsh and broken
harmonies of the harp, has now returned to a state of order following
the accession of James who is credited with tuning the harp's rebellious
strings so that even Orpheus himself wonders at the ensuing sounds. The

45 *Hibernica Respub : ad Iacobum Regem .*

WHILE I lay bathed in my natiue blood,
 And yeelded nought saue harsh , & hellish soundes :
And saue from Heauen , I had no hope of good ,
Thou pittiedst (Dread Soueraigne) my woundes ,
 Repair'dst my ruine, and with Ivorie key ,
 Didst tune my stringes , that slackt or broken lay .

Now since I breathed by thy Roiall hand ,
And found my concord , by so smooth a tuch ,
I giue the world abroade to vnderstand ,
Ne're was the musick of old Orpheus such ,
 As that I make , by meane (Deare Lord) of thee ,
 From discord drawne , to sweetest vnitie .

Basil : Doron .

Cum mea natiuo squallerent sceptra cruore ,
 Edoque lugubres vndique fracta modos :
Ipse redux neruos distendis / Phœbe) rebelles ,
 Et stupet ad nostros Orpheus ipse sonos .

Pœnitentia

Illustration 34 Henry Peacham, *Minerva Britanna* (London, 1612),
 p. 45.

fact that Tyrone and the other rebels, who gave Elizabeth such a dif-
ficult time in the final years of her reign, had already been subdued
before James reached London on his accession is, of course, tactfully
ignored by Peacham. Clearly such emblems pose certain problems if their
heraldic nature is to be indicated in the Index. Possibly cases of the
kind just described could be indicated in the Index Emblematicus by the
addition of the appropriate specific reference. Thus in the instance
of the harp of Ireland the indexer would list "harp [Ireland]." In
this way anyone consulting the Index would be alerted to the fact that

he is looking at no ordinary harp but the heraldic harp of Ireland.
Analogous examples from Peacham's *Minerva Britanna* might result in list-
ings like the following: "Twin Lions, Red and Gold [England and Scot-
land]," "Thistle [Scotland]," "Rose [England]," "Shield [Duke of Lennox]."

To sum up Peacham's achievement as an emblem writer one can say
that his *Minerva Britanna* is the most important published emblem book
prior to that of Francis Quarles. In sheer quantity Peacham's various
emblem collections and his individual emblems make up a major contribu-
tion to the corpus of emblem literature, and I do hope, incidentally,
that the Index will accommodate manuscript material of the kind left to
us by Peacham. As an artist Peacham exhibits a true understanding of
the kind of conceit and wit upon which the emblem depends, and he has
that special talent of being both poet and maker of his own pictures.
His drawings and woodcuts are competent rather than distinguished, but
the mere existence of the latter is, as I earlier suggested, a consider-
able tribute to Peacham and his printer. Peacham's verses tend to be
equally competent but equally undistinguished, though on occasion he is
capable of some very fine verse. I will therefore conclude by referring
to the example of Peacham's emblem for the neglected composer, his
friend John Dowland (see Illustration 35), in which the intensity of his
sympathies gives rise to some moving verses that surpass the general
poetic quality of most of his other poems:

> Heere Philomel, in silence sits alone,
> In depth of winter, on the bared brier,
> Whereas the Rose, had once her beautie showen;
> Which Lordes, and Ladies, did so much desire:
> But fruitles now, in winters frost, and snow,
> It doth despis'd, and vnregarded grow,
>
> So since (old frend,) thy yeares haue made thee white,
> And thou for others, hast consum'd thy spring,
> How few regard thee, whome thou didst delight,
> And farre, and neere, came once to heare thee sing:
> Ingratefull times, and worthles age of ours,
> That let's vs pine, when it hath cropt our flowers.

(p. 74)

Erit altera merces. 74

Ad amicum suum Iohannem Doulandum Musices peritissimum.

Iohannes Doulandus.

Annos ludendo hausi. Anagramma Authoris.

H EERE *Philomel*, in silence sits alone,
In depth of winter, on the bared brier,
Whereas the Rose, had once her beautie showen;
Which Lordes, and Ladies, did so much desire:
But fruitles now, in winters frost, and snow,
It doth despis'd, and vnregarde'd grow,

So since (old frend,) thy yeares haue made thee white,
And thou for others, hast consum'd thy spring,
How few regard thee, whome thou didst delight,
And farre, and neere, came once to heare thee sing:
Ingratefull times, and worthles age of ours,
That let's vs pine, when it hath cropt our flowers.

M 1. *Cui*

Illustration 35 Henry Peacham, *Minerva Britanna* (London, 1612),
 p. 74.

NOTES

[1] *English Emblem Books* (London, 1948), p. 69.

[2] *The More the Merrier* (1608); *Thalia's Banquet* (1620).

[3] *The Compleat Gentleman* (1622), p. 107.

[4] *The Gentleman's Exercise*, p. 25.

[5] The drawing is among the Marquess of Bath's manuscripts at Longleat (Wiltshire): Harley Papers, vol. 1, fol. 159[b].

[6] Freeman, *English Emblem Books*, pp. 47-52; E. N. S. Thompson, *Literary By Paths of the Renaissance* (New Haven, 1924), p. 63.

[7] *The Art of Drawing*, sig. A2[v]. Cf. Nicholas Hilliard's comments in his manuscript treatise of the "Arte of Limning" (ca. 1598-1603), quoted by John Pope-Hennessy in "Nicholas Hilliard and Mannerist Art Theory," *JWCI*, 6 (1943), 92.

[8] Admittedly there is no actual proof that Peacham did prepare his own blocks. On this matter, see the discussion by James Clarke in "Henry Peacham's *Minerva Britanna* (1612): A Bibliographical Description and Analysis," M.A. Thesis, University of Leeds, 1977.

[9] Mason Tung has argued, however, that fifteen of the 248 emblems in Geffrey Whitney's *A Choice of Emblemes* (1586) were "newly devised," conceived both visually and verbally by Whitney ("Whitney's *A Choice of Emblemes* Revisited: A Comparative Study of the Manuscript and the Printed Versions," *Studies in Bibliography*, 29 [1976], 32-101. Whitney's emblem 203 which praises Sir Francis Drake and which pictures his crest, for example, is clearly "English" through and through.

[10] Sig. A3[r].

[11] Alan R. Young, "A Biographical Note on Henry Peacham," *N&Q*, New Series 24 (1977), 215.

[12] See Peacham's Dedicatory Epistle to King James in *Basilicon Doron* (British Library: MS Harleian 6855, Art. 13).

[13] MS Rawlinson, poetry 146.

[14] MS Harleian 6855, Art. 13.

[15] See Dedicatory Epistle to Sir Julius Caesar in *Emblemata Varia*, Peacham's fourth extant manuscript emblem book (Folger Shakespeare Library, MS V. b. 45): "Annus iam agitur decimus septimus . . . ex quo Regiae Ma[ti]: REGIVM illud DONVM, totum in Emblemata versum et picturis

ad vivum delineatis obtulerim quem libellum a sua ma^te: benigniter acceptum, . . ."

[16]MS Royal 12A LXVI.

[17]Peacham's debt to Ripa has been commented upon by Paul Reyher in *Les Masques Anglais* (Paris, 1909), p. 401; by Freeman in *English Emblem Books*, pp. 79-81; and by Allan H. Gilbert in *The Symbolic Persons in the Masques of Ben Jonson* (Durham, 1948), p. 271. Professor Gilbert at one time planned to make a study of this subject and I am grateful to him for permission to read the preliminary notes that he made. The page numbers of the relevant emblems in *Minerva Britanna* are as follows with the corresponding page numbers of the 1603 edition of Ripa in parentheses: 21 (190), 22 (427), 23 (442), 25 (155), 26 (sig. H1^r), 46 (388), 47 (229), 126 (79), 127 (77), 128 (75), 129 (78), 132 (306), 134 (500), 141 (140), 146 (383), 147 (225), 149 (49), 153 (466), 206 (147-48).

[18]*English Emblem Books*, p. 81

[19]*Faerie Queene*, I.i.7. See Ernst Th. Sehrt, "Der Wald des Irrtums: zur allegorischen Funktion von Spensers *Faerie Queene* I. 7-9," *Anglia*, 86 (1968), 491. Cf. Thomas Warton's edition of Milton's *Poems Upon Several Occasions* (1785), p. 106.

[20]*Thalia's Banquet* (1620), sig. A3^r.

[21]Ibid., Ep. 70. See also the four emblems in *The Period of Mourning* (1613) and the prefatory emblem in *A True Relation* (1615).

[22]For a discussion of the provenance and date of this manuscript, see my introduction to the facsimile edition, *Emblemata Varia* (Ilkley and London, 1976).

[23]Though the *Minerva Britanna* collection and most of his individual emblems used woodcut pictures, Peacham may have tried his hand at engraving for the unsigned emblems in *A True Relation* and *The Valley of Varietie*. He may also have engraved the portrait frontispiece to *Prince Henrie Revived* (1615). According to Horace Walpole, he engraved a portrait of Sir Thomas Cromwell after Holbein; see *Anecdotes of Painting in England*, ed. Ralph N. Wornum (London, 1849), pt. III, p. 880.

[24]*The Basilicon Doron of King James VI*, ed. James Craigie (Edinburgh and London, 1944), II. 9.

[25]On the various methods employed to order and unify the collections of other authors, see Thompson, *Literary By Paths*, pp. 46, 51, 53, 59-60.

[26]Whitney makes the theoretical distinction in his preface but makes no attempt to divide his book along these lines.

[27]M. Channing Linthicum, *Costume in the Drama of Shakespeare and His Contemporaries* (Oxford, 1936), pp. 38-39.

[28] *English Emblem Books*, p. 77.

[29] *Emblematum Liber* (1531), sig. A2v.

[30] *The Duty of All True Subjects*, sig. A2r.

JESUIT EMBLEMS: IMPLICATIONS FOR THE INDEX EMBLEMATICUS

G. Richard Dimler, S.J.

Grateful though we are for the Henkel/Schöne *Emblemata*, it is becoming evident both from our individual use and from Peter M. Daly's proposed IE that the Henkel/Schöne *Handbuch* is not completely adequate. Aside from the fact that the editors omit any mention of Jesuit emblems, which comprise an important contribution to the history and development of the emblem, the information provided by the *Handbuch* is in some respects an oversimplification of the full meaning of the emblem in its entirety: motto, *pictura*, and epigram and/or commentary.[1] The illustrations in the *Handbuch* are excellent but although each motto is indexed, the "Bedeutungsregister" or index of meanings is based upon a somewhat overly concise interpretation of the emblem's tripartite structure. For example, in analyzing the Vaenius emblem in columns 739-740, the salamander in the fire, the index records no specific mention of such motifs as "fate" or "the ardor of Cyprius." This lack of specification however is not due to any fault on the part of the editors, since the *Handbuch* is arranged according to a classified index based on Diodor's schematization of Egyptian hieroglyphics taken up later by Pierio Valeriano in his *Hieroglyphica* of 1556.[2] Since the complete meaning of the epigram and the commentary is not indicated in the *Handbuch*, this can be a decided limitation not only for the specialist, but also for the art historian as well as for the literary scholar, theologian, and philosopher. In this respect a more detailed alphabetical indexing of the total emblem as espoused by Daly in his IE would be of considerable value.

In order to indicate more fully the meaning of the emblem and the interaction between motto, *pictura*, and epigram and/or commentary, the latter part of the emblem's tripartite structure must be analyzed in greater detail. It is precisely in the commentary and/or epigram that the emblem writer more frequently reveals the fuller meaning of the emblem. Here the emblem writer offers his particular interpretation of the *pictura* and the interaction of its elements with the motto and accompanying epigram. This explanation by the emblem-commentator of the deeper meaning of the emblem is particularly important for any interpretation or analysis of the Jesuit emblem. As I have shown elsewhere the

Jesuit emblem writer did not construct his emblem in religious isolation
from the mainstream of sixteenth- and seventeenth-century emblem books.[3]
When the first emblem books began to appear at the end of the sixteenth
century, and even during the period of greatest productivity in the
seventeenth and early eighteenth centuries, the Jesuit emblem book mani-
fests certain definite affinities with the secular tradition, in the use
of the motto, *pictura*, and epigram and/or commentary.

To list but two outstanding examples of this affinity between
the Jesuit emblem and the secular tradition--Georg Stengel's *Ova
Paschalia* (Munich, 1634) and the *Imago Primi Saeculi* (Antwerp, 1640)--
approximately 25 per cent of these Jesuit emblems reveal definite simi-
larities with the mottoes, *picturae*, or epigrams of the "common market"
of sixteenth-century secular emblems.[4] In the case of the *Imago Primi
Saeculi*, we find parallels with, to name but a few examples, the candle
emblem in Jacob Cats, *Emblemata moralia* (Rotterdam, 1627), No. 20 and
Imago Primi Saeculi, p. 180; Ulysses and the sirens, Alciatus, Held
translation (Frankfurt, 1557), No. 94 and the *Imago Primi Saeculi*, p.
181; the beehive in Camerarius, *Symbolorum et Emblematum ex volantibus*
(Nürnberg, 1595), No. 90 and *Imago Primi Saeculi*, p. 471; Amor and the
soap bubbles, Heinsius, *Het Ambacht* (Leyden, 1595), No. 21 and *Imago
Primi Saeculi*, p. 186; the bear licking its cub in de la Perrière, *Le
Theatre des bons engins* (Paris, 1539), No. 98, Vaenius, *Amorum emblemata*
(Antwerp, 1609), pp. 56-57 and *Imago Primi Saeculi*, p. 465; the salaman-
der in Camerarius, *Symbolorum et Emblematum ex aquatalibus* (Nürnberg,
1604), No. 69, Cats, *Proteus* (Rotterdam, 1627), No. 16, Vaenius, *Amorum
emblemata*, pp. 228-29 and *Imago Primi Saeculi*, p. 727; and finally
Arion and the dolphin in Alciatus, Held, No. 159, Rollenhagen, *Nucleus
emblematum* (Arnheim, 1611), No. 10 and *Imago Primi Saeculi*, p. 938.
Likewise correspondances exist between the *Ova Paschalia* and leading
sixteenth-century emblem books: the salamander occurs in emblem 97 (cf.
Vaenius, *Amorum emblemata*, pp. 228-29); storks feature in emblem 68 (cf.
Alciatus [1531], A3b and Held, No. 72); zodiac and glove in emblem 1
(cf. Vaenius, *Amorum emblemata,* pp. 36-37, Custos, *Emblemata amoris*
[Augsburg, 1622], Nos. 18-19).

Thus the Jesuit writer and engraver were aware of and frequently
influenced by sixteenth- and seventeenth-century emblem books. But what
is of considerable importance in the Jesuit assimilation of these secu-
lar emblems is their adaptation of the emblem for their own purposes--
which in many cases was further determined by such themes from the
Spiritual Exercises of Ignatius Loyola as man's final goal, the use of

creatures, the Kingdom of Christ and its conflict with Satan, loyalty to
Christ the King, discernment between the influence of good and evil
spirits, and so forth.[5] In addition to these Ignatian themes there is
also the further influence of the Jesuit seventeenth-century apostolate:
the defence of the faith, the teaching of catechism to the young, the
establishment of colleges and schools, and the counter-reformation
movement. These factors are important since such emblems as the bear
licking its cub, Ulysses and the sirens, Castor and Pollux, Narcissus
gazing at his reflection are applied by the Jesuits for a different pur-
pose than was intended in their original emblematic context by a Cats,
Rollenhagen, or Zincgref. This difference in interpretation is of vital
importance and frequently is found in the epigram and/or commentary.

 This is not to suggest that the Jesuits were the crass propagan-
dists implied by Mario Praz.[6] The Jesuits were also careful to make
their emblems works of art, fashioned in conformity with the highest
standards of the emblematics of the age. We need only call to mind
Hermann Hugo's *Pia Desideria* (Antwerp, 1624), the plates in Drexel's
Orbis Phaeton (Munich, 1629), Menestrier's *L'Art des emblems* (Lyon,
1662), the close cooperation of the Plantin Press, the Wierix brothers,
the Galle Family, and Rubens with Jesuit writers and churches, or the
ingenious plates with the 100 egg-emblems in Stengel's *Ova Paschalia*
(Munich, 1634). Rubens was commissioned by Charles Scribanus (1561-
1629), who was himself the author of several emblem books, among them
the *Amor Divinus* (Antwerp, 1615) with engravings by the famous Sadeler,
to the ceiling painting for the Jesuit church in Antwerp.[7] The famous
Cornelius Galle did the engravings for the *Imago Primi Saeculi*; Boece à
Bolswert, another famous and distinguished engraver, produced the peli-
can emblem for Antoine Suquet (1574-1627), *Via viae aeternae* (Antwerp,
1620), plate 25. Jan David (1545-1613) commissioned the great engraver
Theodore Galle (1571-1633) to do the *pictura* of the monkey and its cubs
for emblem 4 of his *Duodecim Specula* (Antwerp, 1610) produced at the
Plantin Press.[8] The Plantin Press also produced Willem Hesius (1601-
1690), *Emblemata sacra* (Antwerp, 1636). Moreover the first painted
enigma originated at the Jesuit College at Pont-à-Moussin in 1588.[9]
But the Jesuit writer reshapes the emblem, he gives it further defini-
tion and extension, and this has considerable importance for any index-
ing process when applied to the Jesuit emblem. The precise determina-
tion of items, motifs, and meanings which are to be indexed must be
carefully established. The well-known bear and cub motif as used in
de la Perrière or in Vaenius is transformed in the Jesuit emblem book.

In de la Perrière's epigram the accent falls on the formation of the human spirit through teaching. In the *Imago Primi Saeculi*, p. 465, the epigram for this same *pictura* states that the meaning of the emblem is as follows: the Jesuit preacher is the bear who licks the cub (mankind) into form and shapes the cub by proclaiming the Good News of the Gospel. Thus, if we are to index properly the Jesuit emblem, care and consideration must be given to the function of the epigram and/or commentary in redefining and reinterpreting emblems appropriated from the secular tradition.

Moreover, it happens not infrequently that additional icons are added by the Jesuit engraver to the assimilated *pictura*. For instance, in the salamander emblem in the *Imago Primi Saeculi* (p. 727) a crown has been added to the salamander to show that Blessed Charles Spinola has achieved the crown of martyrdom by fire; Cosmas and Damian are substituted for Castor and Pollux in *Imago Primi Saeculi* (p. 46), since the Society of Jesus was founded on the feast day of Saints Cosmas and Damian (September 26). Orpheus is transformed into a prototype of Jesus (cf. *Imago Primi Saeculi,* p. 467); the egg in Stengel is used symbolically as a resurrectional motif; zodiacs become symbols of the Divine Presence and control in the world (cf. *Ova Paschalia*, Emblem 1). These adaptations and transformations of typical emblems conform with the Jesuit principle of "finding God in all things," or the sacred letters I H S, the symbols of the Society, which are frequently found emblazoned on the sun, or the beehive symbolizing the Jesuit educational apostolate, or the bird of paradise symbolizing Ignatius Loyola's search for God (cf. *Imago Primi Saeculi*, p. 715). In sum, both the additional icons introduced into the traditional *pictura* and the further explicitation of the higher meaning of the emblem provided in the commentary suggest the need for an IE that would be more complete and more highly differentiated than the Henkel/Schöne handbook.

In order to incorporate the features of Jesuit emblems noted above, I propose a revision of the IE schema as outlined in Daly's paper. I have selected at random eight emblems from among some 400 Jesuit emblem books. Each emblem will be analyzed and indexed according to the following basically tripartite schema: (1) *Summary Leitmotif*, (2) *Pictorial Motifs,* (3) *Epigrammatical Motifs and Concepts from the Commentary and/or Epigram*. Before applying this revised analysis model, I should perhaps explain and define these three categories.

By *Leitmotif* is meant the dominant, pervasive idea, which can be summarized in a brief descriptive phrase and which integrates the tri-

partite emblematic structure. It functions as a general basic intro-
ductory statement enabling the user of the IE to achieve an initial
grasp of the overall theme of the emblem. Frequently in the Jesuit
emblem this is clearly indicated by the writer himself. For example,
from among the eight specimen emblems I have selected for analysis, the
Leitmotif in Julian Hayneufve, *Scala Salutis* (Cologne, 1650), emblem no.
1 is "The One Thing Necessary" (*unum necessarium*) which is already
indicated in the Jesuit motto; or emblem no. 1 in Carlo Bovio, *Ignatius
Insignium* (Rome, 1655), "Ignatius brings added renown to his heritage"
(*quod accipit auget*) or in Heinrich Engelgrave, *Lux Evangelica* (Antwerp,
1648), emblem no. VII, the *Leitmotif* would be "Pain of the Damned"
(*dolentes quaerebamus te*); in Stengel, *Ova Paschalia* (Munich, 1634),
emblem no. 97, the *Leitmotif* would be "Eternal Fire" (*ignis aeterni*),
and finally in the *Typus Mundi*, pp. 12-13, the *Leitmotif* is "The world
has been placed in evil [tree of the apple]" (*Mundus in ma-li ligno
positus est*). These basic *Leitmotifs* serve as dominant threads of mean-
ing binding together the tripartite structure of the entire emblem. The
Leitmotif binds together the dynamic interaction of motto, *pictura*, and
commentary and/or epigram.

Careful analysis of the Jesuit emblem has brought us to the con-
clusion that this *Leitmotif* becomes clear in the cursory mottoes and
subscriptions which often accompany the emblem. We propose that this
Leitmotif serve as an initial attempt to introduce the user of the pro-
posed catalogue to Jesuit emblems and will be listed after "I" on the
IE card. This initial listing can, of course, be refined and improved
after completion of the catalogues and after it has been submitted to
review by the editors of the IE and interested scholars. I also sug-
gest that these *Leitmotifs* be accompanied by the descriptive motto or
subscriptio if they coincide in meaning.

In category 2 the pictorial icons (or elements) will be found;
all central motifs in the *pictura* will be listed along with secondary
motifs if they are mentioned in the epigram and/or commentary beneath
the *pictura*. For example, in the first emblem in Stengel's *Ova Pas-
chalia*, whose *Leitmotif* (I) is "Knowledge of God in World, Egg" (*Ovi,
Mundi, Dei Cognitio*), the icons egg, globe, sun, moon, should all be
listed since they are explicitly mentioned in the commentary and they
are central motifs. The four border figures--bird, fish, turtle, eagle--
need not be included since they are neither mentioned in the epigram
and/or commentary nor do they add significance to the meaning of the
emblem. However, the zodiac would be listed in category II, *Pictorial*

Icons, even though it is not mentioned in the epigram and/or commentary since it is a central dominant icon immediately evident to the eye of the beholder. It is an obvious symbol for the presence of God in the world and is prominently displayed in the *pictura*. Likewise in the emblem in the *Imago Primi Saeculi*, p. 329 whose *Leitmotif* is "Aloysius's Call and Response to Greatness," it is obvious that the sun, the bird flying to the sun, and the mother bird in the nest should be given as the *Pictorial Icons*. However, there is no need to include the tree or the field in the background since they are not mentioned in the epigram and/or commentary or the motto, nor are they central motifs in the *pictura*. We believe that this *modus agendi*, that is, listing only dominant icons in the *pictura* or those mentioned in the accompanying epigram and/or commentary, reduces the danger of subjectivity. It will also help to eliminate the very real difficulty in attempting to distinguish between primary and secondary motifs, a problem raised in Daly's paper (pp. 7-11 above).

In category 3 on the IE card concepts and motifs from the epigram and/or commentary will be listed; that is, those which have not been previously entered under categories I or II. If the listings under I and II exhaust all the concepts from III, this section will be left blank. However in Stengel's *Ova Paschalia*, emblem I we find a clear reference to the Blessed Trinity in the extended discussion of this emblem. But the Trinity is nowhere pictorialized in the *pictura*, hence this notion would have to be listed under category 3. Likewise, the notions "infinity" and "eternity" occur later in the same commentary by Stengel but are not found in the *pictura*. Similarly, in the *Imago Primi Saeculi* emblem on page 187 Narcissus is not named either in the motto or the epigram, nor does he appear in the *pictura*, but he is explicitly mentioned in the epigram beneath the *pictura*. Thus "Narcissus" must be listed under category 3, *Epigram and/or Commentary Motifs and Concepts*. This third category will be of considerable importance in our analysis of the Jesuit emblem since frequently by means of a thoelogical or classical commentary the Jesuit writer adds a further dimension to a traditional interpretation of an emblem, and this added interpretative concept must not be omitted lest the full significance of the emblem be lost.

The following is an attempt at an analysis of eight Jesuit emblems on the basis of our proposed model, which is a revision of that outlined by Daly. Each card will have three basic listings running down the left side of the card: (1) *Leitmotif*; (2) *Pictorial Icons*;

(3) *Epigram-Commentary Concepts and Motifs*. The top right hand of the card will be the same as in the Daly Index and beneath it will be the emblem reproduction.

Leitmotif	*Author*		*Short Title*		
	date	*place*	*language*	*no. of ill.*	*no. of cards*
Pictorial Icons					
Epigram-Commentary Concepts and Motifs					

Leitmotif First Principle (unum necessarium)	*Author* Julius Hayneufve		*Short Title* *Scala Salutis*		
	date 1650	*place* Köln	*language* Latin	*no. of ill.* 1	*no. of cards*
Pictorial Icons Ship Harbor					
Epigram-Commentary Concepts and Motifs Life's Final Goal					

Leitmotif	*Author* H. Engelgrave	*Short Title* Lux Evangelica			
Pain of the Damned	*date* 1648	*place* Ant- werp	*language* Latin	*no. of ill.* VII	*no. of cards*

Pictorial Icons Falcon Hand Rope Prey	

Epigram-Commentary Concepts and Motifs Longing for God in frustration Torment at Loss of God Falcon Frustrated	

Leitmotif	*Author* Carlo Bovio	*Short Title* Ignatius Insignium			
Ignatius brings added renown to his heritage (*Quod accipit auget*)	*date* 1655	*place* Rome	*language* Latin	*no. of ill.* 1	*no. of cards*

Pictorial Icons Phial Candle Light	

Epigram-Commentary Concepts and Motifs Sanctity Nobility	

Leitmotif	Author	Short Title
Knowledge of God in World Egg (*Dei in mundo, ovo, cognitio*)--	Stengel	Ova Paschalia

date	place	language	no. of ill.	no. of cards
1634	Munich	Latin	1	

Pictorial Icons

Globe Sun Moon Stars Zodiac Egg

Epigram-Commenatary Concepts and Motifs

Trinity Crocodile Infinity Aeternity

I.

Ovi, Mundi, DEI cognitio.

EMBLEMA I.

COMPENDIUM SCIENTIÆ EST,
IN OVO MUNDUS, IN MUNDO DEUS.

X ovo alii vitellum, pullum alii t. quærunt, ego in eo totum Mundam reperio. Neque ego tantùm. Nam & I ttebius *lib* 3. *de præparat.* *Evang.*c.tc Pythagora docet,ovi *testam* omnia clau tentis claudatur,*vitellum* igni ;lpiritus. qui funt in ovo,ser: alhumen aqua,partes mages concretas, terræ in hierog'yphicum elle. Theron. Cardanus *lib.* 7. *de rer. variet.* c. 29. de ovis loquens, Quandam, inquit. *elementorum & Universi speciem,fed converfam præbere videntur.* Nam quod

Leitmotif	Author	Short Title
Aloysius's Call and Response to Greatness (*Non-inferiora secutus*)		Imago Primi Saeculi

date	place	language	no. of ill.	no. of cards
1640	Antwerp	Latin	p. 329	

Pictorial Icons

Nest Birds Sun

Epigram-Commentary Concepts and Motifs

Family Fame Jesus

LIBER SECVNDVS SOCIETAS CRESCENS. 329
B. Aloyfio Societatem IESV ingredienti.

Non inferiora secutus.

Leitmotif	Author		Short Title		
Spotless Chastity (*vapor rapit omne decus*)	date	place	language	no. of ill.	no. of cards
	1640	Munich	Latin	p. 187	

Pictorial Icons

Amor Mirror Breath Image

Imago Primi Saeculi

LIBER PRIMVS. SOCIETAS NASCENS. 187
Caftitas fit intaminata.

Vapor rapit omne decus.

Epigram-Commentary Concepts and Motifs

Narcissus Lily Stars

Leitmotif	Author Antwerp College		Short Title		
The World has been placed in evil (the tree of the apple)	date	place Ant- werp	language	no. of ill.	no. of cards
	1627		Latin		

(*Mundus in ma-li ligno positus est.*)

Pictorial Icons

Adam Eve Apple
Tree Snake

Epigram-Commentary Concepts and Motifs

Pindus Ossa
Parnassus Atlas

Typus Mundi

12 TYPVS

Totus mundus in maligno mali ligno positus est.

Leitmotif	Author		Short Title			
	Stengel		Ova Paschalia			
Eternal Fire	date	place	language	no. of ill.	no. of cards	
(Ignis aeterni)	1634	Munich	Latin	97		

Pictorial Icons Salamander Eggs Fire	
Epigram-Commentary Concepts and Motifs Eucharist St. Kunigund-exemplar Three Boys in Babylon	

In conclusion, the *Leitmotifs* can be arranged alphabetically as proposed in the Daly IE. The key words in the statement of the *Leitmotif* will be asterisked to aid in the indexing and cataloguing process. The key pictorial icons under 2 will be likewise indexed alphabetically in a separate filing, as well as the terms under 3. If the data were computerized all these key words could be retrieved later through the computer. Thus each division will be filed alphabetically according to each term listed on each card. Only the main card will contain (1) *Leitmotif*, (2) *Pictorial Icons*, and (3) *Epigram and/or Commentary Concepts and Motifs* plus the picture. Files 2 and 3 will contain cross-references both to the main *Leitmotif* card and to each other. Obviously this initial index will need later refinement after completion of the preliminary indexing process. It should be submitted to the scrutiny of potential users of the IE, be they theologians, emblem specialists, art historians, literary critics, linguists, philosophers, or sociologists. We believe that such an IE would provide an essential service to the academic community.

NOTES

[1]With the help of grants from the National Endowment for the Humanities, The American Council of Learned Societies, The German Academic Exchange Service and the Fordham University Office of Research Services, I have located some 400 Jesuit Emblem Books. The results of this research are being published serially in the *Archivum Historicum Societatis Jesu*: "A Bibliographical Survey of Jesuit Emblem Authors in German-Speaking Territories: Topography and Themes," *AHSJ*, XLV (1976), 129-38; "Jesuit Emblem Books in the Belgian Provinces of the Society (1587-1710): Topography and Themes," *AHSJ*, XLVI (1977), 377-87; "A Bibliographical Survey of Jesuit Emblem Authors in French Provinces 1618-1726: Topography and Themes," *AHSJ*, XLVII (1978), 240-50. A survey of Jesuit College Emblem Books will appear in 1979.

[2]Henkel/Schöne, *Handbuch*, p. xxii.

[3]Cf. "The Egg as Emblem: Genesis and Structure of a Jesuit Emblem Book," *Studies in Iconography*, 2 (1976), 85-106 and "The *Imago Primi Saeculi*: On Jesuit Emblematics, Origins and Methods," to be published in the Eli Sobel Festschrift.

[4]Cf. "Egg as Emblem," 102-103 and *Imago Primi Saeculi*," appendix.

[5]Cf. John B. Knipping, *Iconography of the Counter-Reformation in the Netherlands* (Leiden, 1974), I, 67ff.

[6]*Studies in Seventeenth Century Imagery* (Rome, 1964), pp. 169ff.

[7]Cf. Knipping, *Iconography*, I, 9ff.; Dimler, "Jesuit Emblem Authors," *AHSJ*, XLVI (1977), 383 and *Baroque Art: The Jesuit Contribution*, ed. Rudolf Wittkower and Irma B. Jaffe (New York, 1972), pp. 10-11.

[8]Cf. Knipping, *Iconography*, I, 18-19.

[9]Cf. Jennifer Montagu, "The Painted Enigma and French Seventeenth Century Art," *Journal of the Warburg and Courtauld Institute*, 31, (1968), 307ff.

EMBLEMS IN SOME GERMAN PROTESTANT BOOKS OF MEDITATION: IMPLICATIONS
FOR THE INDEX EMBLEMATICUS

Peter C. Erb

Despite the remarkable growth of interest in Christian contemplative literature over the past two decades, and the special attention given to Roman Catholic (particularly Jesuit) and Puritan treatises on meditation,[1] there are surprisingly few studies which treat the spirituality of German Protestantism of the sixteenth and seventeenth centuries. Paul Althaus's call in 1914 for a full review of the prayer literature of the period has, for the most part, been left unheeded.[2] We still await a reliable bibliographical guide to the numerous books of meditation published in Protestantism's first two centuries. The hope of making any reasonable statements on the principles and practices of Protestant meditation must await fuller studies of Protestant spiritual texts, of the sources of their contents and form, of their various methods of devotion, of the psychology and sociology of the prayer life of the period, of details on Protestant ascetic and mystical theologies, and of the relationships between those various spirtualities which arose out of the Magisterial and Radical Reformations.

Among the clues available for understanding German Protestant spiritualities, the emblems which appear in various books of meditation are particularly useful. Chief among these books is Johann Arndt's *Wahres Christenthum*, without a doubt the most influential book of meditation in German Protestantism. *Wahres Christenthum* eventually appeared as six books; the first was published in 1605 and was revised and printed with three more books in 1606. In later editions two more books were added, one composed of three treatises by Arndt, and a second made up of his defence of his earlier four books. Consistently upholding the Lutheran doctrine of salvation by grace through faith, *Wahres Christenthum* insists on the need for heartfelt repentance, the experience of the new birth, the practice of piety in devotion and prayer and in acts of love for God and neighbour expressed together in and toward the renewed image of God in man. The popularity of Arndt's work was exceptional. *Wahres Christenthum* went through twenty editions before the author's death and an additional 125 editions before the close of the eighteenth century. No complete listing of nineteenth-century printings has been done.[3]

In 1678 some sixty emblems were added to the first four books of
Wahres Christenthum; these included an emblematic frontispiece for the
work at large and one for each of the six books.[4] For the IE the em-
blems in any single edition of Arndt's *Wahres Christenthum* (or in any
of his other works, particularly his prayerbook, the *Paradiesgärtlein*[5])
will not raise any peculiar problems. Each emblem is composed of five
parts: a motto, a *pictura*, a prose "exegesis," a Scripture citation,
and a poetic "exposition." In no case, the indexer will be relieved to
know, is there direct reference from emblem to the text of *Wahres
Christenthum* or from Arndt's work to the emblem; the emblems can be
treated separately.

By the statement that the emblems can be treated separately, I
am not suggesting that they have no relationship whatever to Arndt's
book. They are, indeed, especially fitted for the themes of his work and
add a dimension to the volume lost to so many modern readers who are
anxious only to skim the text to gain a knowledge of Arndt's theological
position. Such readers inevitably comment on the "repetitive redun-
dancy" of Arndt's text, and they thus miss the work as a whole. *Wahres
Christenthum* is, after all, a book of meditation and is to be approached
as such. The emblems direct our attention to this fact. Despite the
fact that Arndt did not plan his work to contain emblems, they are an
integrated part of later editions and do provide an important element in
the meditative purpose of these works. All in some way treat the theme
of the new life in Christ as growth toward the renewed image of God in
man. A key motif in all is light. Light in some form (usually the sun)
is a primary motif in almost half the emblems included. A Christian
must reflect the true light, God, as a mirror reflects sunlight; God's
light shines over all as the sun shines over the world; the morning
light signifies the new light in Christ and the resurrection. An addi-
tional one-quarter of the emblems treat light in a secondary way. By
a star in the darkness we guide our lives; as sinful men we chase our
shadows and forget the sun; as eagles we are to fly toward the light.
All the remaining emblems are depicted in most editions so as clearly to
reflect light. Even when light is not a secondary motif, the *pictura*
is often designed to make the viewer aware of lighting. Another such
theme which, although not always treated in the "exegesis" or "exposi-
tion," but which often appears in the *pictura*, is the image of the tree.
In about one-sixth of the emblems, the tree is a primary motif, but in
almost all a tree, either dying or flourishing, appears, stimulating the
reader to consider the new life possible in Christ the vine, or the need

to bring forth good fruits in a new life. The remaining primary motifs
vary: the newborn child, bees and ants, organs, clocks, the pearl,
printing presses, a fountain, a bird in a cage.

It cannot be my primary purpose in this paper to discuss the
various ways in which the emblems and their motifs are aids in devo-
tional practice, but a brief review of their role can be given. Each
emblem is placed in the text to expand the particular topic under dis-
cussion. Thus, in Book I, chapter 5 (see Illustration 36) which treats
true faith, an emblem titled "By power from above" is inserted, telling
the reader,

> Here is a lens through which the sun shines.
> As a result wood is ignited and burned. This
> lens is true faith which is united with the
> sun of righteousness enlightening the heart
> of man through power from above and igniting
> the fire of heart-felt love in him.

The Scripture passage paraphrased is Ephesians 1:19; a verse exposition
treats the Sun of Righteousness.

All emblems in *Wahres Christenthum* are inserted to direct the
reader to the major themes of the work. They are guides for the believ-
ing reader so that the meditator does not become caught up in topics of
secondary importance. This is not to suggest that the emblem enclose
the meditation; they heighten aspects of the text for meditation, but in
so doing they also open new themes for consideration. I have already
noted the depiction of motifs in the emblem not treated in either prose
exegesis or poetic exposition. Thus, in the emblem described above, the
lens is set in some editions on a pedestal on which is a tree image, the
tree of life, or the vine into which the believer is implanted.

The existence of such motifs raises a serious problem both for
the indexer and for the student of Arndt's work as an example of
Protestant meditation. The numerous editions of *Wahres Christenthum*
which existed prior to the mid-eighteenth century cannot be simplisti-
cally looked upon by students of contemplative literature as many
reprintings of the same work, because the emblems in these editions were
often redone. Primary and secondary motifs remain the same in the em-
blems of all editions, but the setting of the emblems is often changed
throughout the printing history of the volume, and when different motifs
are entered the meditative tone of the work is also changed. For exam-
ple, Book IV, Part II, chapter 13 treats the theme of God's love which
is primary in all His works, even in His punishment of man. The emblem
printed with the chapter pictures a kiln the heat of which purifies and

Durch krafft von oben.

Illustration 36 Johann Arndt, *Wahres Christenthum* (Philadelphia, 1751), p. 27.

strengthens the objects in it. In a nineteenth-century printing of *Wahres Christentum* a heart is pictured in the kiln (see Illustration 37). The distinction between the meditative direction of the two is obvious, the one directing attention to the burning generally, the other direct-

Illustration 37 Johann Arndt, *Wahres Christenthum* (Philadelphia, 1856), p. 622.

ing it to the specific object of the burning. Also obvious is the difficulty for the indexer. The heart is not mentioned in any textual explications of the emblem but is an important motif in the *pictura* and in the meditation. Consequently, to index the emblems in Arndt fully, it would be necessary to do a study of the development of the emblematic

"additions," their relationships to one another, and their relationships
to the text. To my knowledge this has not yet been done, but since the
additions are late it is doubtful whether their inclusion in an index
would be of value for anyone but the student of Arndt's influence.

 The problem of the emblematic "additions" in the later printings
of Arndt's *Wahres Christenthum* reflects what is a common factor in much
contemplative literature: because contemplative literature is created
to inspire a believer to meditation and devotion, the form of books of
meditation is often changed by later writers. German Protestants,
especially those of the sixteenth and seventeenth centuries, regularly
reworked earlier contemplative treatises to suit their contemporary
needs. The texts of medieval mystics were often rewritten as were pray-
ers, hymns, and sermons of other religious denominations and languages.
Arndt's *Wahres Christenthum* serves as an excellent example of this prac-
tice, since in large part it is a reprinting and reworking of selected
texts from Angela of Foligno, Tauler, the *Theologia deutsch*, the *Imita-
tio Christi*, Valentine Weigel, Paracelsus, and others.

 Because of the practice of reworking earlier texts, prayer books
and books of devotion often differ in intention from the original inten-
tions of the authors whose works supplied sources for the later works.
Moreover, devotional works were often expanded after their first compila-
tion. It is therefore not possible for the student of much contemplative
literature to reach back simply to a first or a "critical" edition of a
work and to thereby claim the "fullest" form for any point in time. The
Augustine of the *CSEL* for example or of the *Corpus Christianorum* is not
necessarily the Augustine of Luther or Calvin; their Augustine can still
be found more directly in Migne's *Patrologia*. The same holds true for
Bernard and many books of meditation.

 One Protestant example of a devotional work which must be studied
in light of its historical development is Jacob Boehme's *Der Weg zu
Christo*. This work is easier to handle than some meditative treatises of
the period because even in its expanded version it contains material
written only by Boehme himself.

 As I have pointed out elsewhere[6] *Der Weg zu Christo* exists, in
title and form, because of the Boehmist tradition and not because of
Boehme. On New Year's Day 1624 Boehme's friends printed, seemingly
without his knowledge, three of his treatises: *On True Repentance, On
True Resignation,* and *On the Supersensual Life*. The work was reprinted
in 1628 to include *On the New Birth* and other smaller pieces. In this
form it was translated by Sparrow into English in 1648. With other

slight additions, Sparrow included *The Conversation Between an Enlight-
ened and Unenlightened Soul*. Johann Georg Gichtel, the most important
of Boehme's editors, interpreters, and popularizers in the late seven-
teenth century, printed *The Way to Christ* with its present contents for
the first time in 1682. Gichtel knew of all earlier printings of the
work and of individual publications of the separate treatises in Dutch
and German, and was concerned to establish an order of the treatises
that would best serve the uninitiated reader. His order, with one
slight variation (Gichtel's third treatise was reprinted as the second
because it treated the same theme as the first), was maintained by later
editors.

 The treatises as they were printed were to mark stages on the
way to Christ. After proper repentance (treated in the first two trea-
tises; the second treatise was generally printed as an addendum to the
first), the reader is to pray properly (the third treatise), resign him-
self fully to God (the fourth treatise), experience the dimensions of
the new birth that results from such resignation (the fifth treatise),
and grow in divine contemplation (the sixth and seventh treatises). The
eighth treatise is a dialogue summation of the earlier works; the
ninth provides practical advice for souls who walk on the path of the
new birth. As the reader proceeds, the language becomes ever more tech-
nical, the structure more contorted, and the ideas more difficult to
grasp. The reader is progressively introduced into the Great Mystery.
Reading is not a simple activity of the mouth; it is an incorporation of
the principles seen by the reader. The reader is called upon to under-
stand, to know intellectually and emotionally, the depth of the subject
treated. The Great Mystery to which he is introduced is the Mystery of
the divine and is thus infinitely understandable. Boehme is aware that
all reading and viewing involves a shaping of consciousness and there-
fore he warns his reader at the very beginning not to continue if he is
not in earnest. The person who finishes a book is not the same person
who began it. If he understands its content even in part, he takes
upon himself a great burden. He must accept and follow, accept and not
follow, or reject the contents. Whichever he does, he reforms his ori-
entation in an unchangeable way. The reader is not the same man he was
before he began to read Boehme's words; he is one who has heard the
words and has gained insight from them, or one who, having seen the
words, considers them of no consequence and sets them aside. His con-
sciousness thereafter will be different because of this encounter.

It is to the one who has experienced the encounter that the emblematic contents printed in the *Weg* are directed. As a result, the emblematic additions to the *Weg* and to other Boehmist literature are sometimes included without explanations of their content. The earnest reader is to have no need of explanatory material; the reader not in earnest is safer without it. Despite this, however, explanations are most often appended. For example, the 1730 edition of *Der Weg zu Christo*,[7] the best edition of the work printed, includes such explanations even when the *pictura* can be easily understood. Thus, the frontispiece to the fourth book on the new birth (see Illustration 38) depicts in the cross at the centre of the illustration the birth of all things and the new birth itself according to the explanation. Its roots are in sin and death but it can reach toward a new life in the Spirit.

For the indexer the emblems in Boehme's work and in much Boehmist literature are no more difficult to handle (in those cases in which explanations are added) than are the emblems in Arndt's work. Indeed since, in the case of *Der Weg zu Christo*, there are fewer editions of the work than there are of *Wahres Christenthum* and since the emblematic structures were not redone as often, the difficulties are fewer.

The major problem which arises for a student of the emblematic content of *Der Weg zu Christo* and other Boehmist literature, however, is the relationship of the highly complex emblematic illustration to the text as a whole. Whereas in Arndt emblem can be separated from the text and treated accordingly, in Boehmist literature it is often so closely bound not only to a particular text but to the thought structure of Boehmism as a whole that it cannot be simply extracted and categorized. That we are not dealing with emblem proper in *Der Weg zu Christo* and that an indexer of emblems could therefore ignore them does not solve the problem, for in much other Boehmist literature (by Abraham von Franckenberg and Johann Theodor von Tschesch) emblems do appear in their more "classical" form, and Boehmist emblematic material was influential in later German as well as English literature.

In the Boehmist literature of which I am here mindful the emblem is illustrative of text; the emblem is, as it were, used as a source for speculative contemplation whereas in Arndt it is used as an element in affective devotion. In both the Boehmist literature and Arndt, however, illustration is separate from text in that in neither case is it necessary to have the illustration to understand the text. In Arndt's case the illustration expands the devotional possibilities of the text and in

the Boehmist literature it serves among other ways as a mnemonic device for a highly complex speculative system.

Illustration 38 Jacob Boehme, *Der Weg zu Christo* (Amsterdam, 1724), frontispiece.

In a third type of Protestant book of meditation text and illustration are much more closely bound together, and for the student of meditation as well as for the student of the emblem intent on indexing his primary sources, new problems are raised. This third type of book is best exemplified by the works of the Strassburg contemporary of Arndt and Boehme, the mystical spiritualist Daniel Sudermann.[8]

Sudermann's father was a goldsmith and Sudermann himself was trained in engraving and etching. With Johann van der Heyden, who etched most of Sudermann's major poetic books of meditation, Sudermann published in 1624 his emblem book *Centuria similitudinum.*[9] For the present purpose, however, attention is best directed not to his emblem book, but to the five parts of his *Schöne auserlesene Figuren* and above all to his *Hohe geistreiche Lehren.*[10] Together these works contain some 300 folios each containing an epigram as title, a *pictura,* and a long poetic meditation inspired from (but not necessarily written on) the *pictura* (see Illustration 39). In almost all cases a prose passage (usually taken from a medieval mystic) related to the theme of the poem is also given. In Sudermann the *pictura* serves as a starting point for the poet. There is often much in the poetic *meditation* not specifically *pictured* in the illustration. The poem in most cases develops far beyond the content of the illustration, which is often quite simple and in many cases is composed only of one or two human figures. Sudermann intended his books to be used as books of meditation and despite the "content" difference between text and illustration, they are never separate for the meditator, whose eye is regularly drawn back to the illustration from the text. The illustration from the *Hohe geistreiche Lehren* already referred to (Illustration 39) offers a good example of Sudermann's technique. The *pictura* and the poetic meditation have only two things in common: the way to the cross, and the action of being drawn or pulled. The *pictura* draws the meditator's attention to the bound hands, to the hand of God, and, in the form in which the cross is portrayed, to an image of the Trinity. The poem contains none of these images but discusses other matters not reflected in the *pictura*: *Brautmystik* imagery, pain and suffering in the path to the cross, the specific relationship of the Father to the Son in salvation, the mystical experience of seeing God face to face. Only in the prose addendum is the paradoxical aspect of the epigram "Draw me toward you and we [i.e., I] shall walk" discussed more fully. The further implication of the epigram that if God draws man to Him, we, i.e., man and God, will walk *together* is left for the

meditator to discover in his continual movement from text to illustration and back again.

Illustration 39 Daniel Sudermann, *Hohe geistreiche Lehren* (1622), p. 3.

To index these emblems solely from the illustration would be to do great damage to their full purpose and yet, to ascertain their meaning from the poetic meditation is to falsify and in some ways to close the manifold "openness to being" in the figures which Sudermann as a mystical Spiritualist saw possible within all creation and thus within the illustration done by van der Heyden as well. The figures in Sudermann's work are static, just as the figures in emblems tend to be, but in the design of the figures in Sudermann's works, and in the movement of the meditator's mind along the patterns of rhythm and image in the poems and in the movement of his eye from text to illustration and

back to text again, those figures take on a fluidity intended to lead
the active mind outward and upward away from creatures toward the divine.

It is this activity and the role of this activity in books of
meditation, the most significant element in Sudermann's work, which was
missed three-quarters of a century later by Gottfried Arnold (1666-
1714), the Lutheran theologian, poet, historian, and compiler of books
of meditation.[11] The influence of emblem books on Arnold has not yet
been studied but is evident at many points in his work, particularly in
his poetry. There is a strong influence of Arndt's *Wahres Christenthum*
and its emblems on Arnold. Moreover, over five years of his life
Arnold was directly indebted to the Boehmist tradition and read and med-
itated upon their emblematic illustrations and texts. In addition,
Arnold's collection of poetry, the *Poetische Lob- und Liebes-Sprüche*,
is in large part a reworking of Sudermann's *Hohe geistreiche Lehren*;
Sudermann's marginal annotations from medieval mystics are reprinted
in Arnold, but interestingly Sudermann's *picturae* are not.[12]

Arnold's first book of poetry, the *Göttliche Liebes-Funcken*,[13]
contains many poems directly inspired by the emblems of Dilherr and
there are times when one reads these poems that one has a sense of the
movement which is apparent in the Sudermann pieces. Arnold's poetic
development can be seen as a development away from the *pictura*. In his
Göttliche Liebes-Funcken picturae are included but in later poems they
are omitted even when his images (e.g., the magnet of love)[14] and the
epigrammatic titles to his poems [15] indicate that his source of inspira-
tion was the emblem tradition.

Arnold found himself forced by the power of his poetic argument,
the drive of his "baroque personality," and the dynamism of his pietis-
tic brand of spiritualism to burst beyond the visual (indeed even beyond
the literal) toward that which he had discussed in his Master's disserta-
tion[16] and towards which he had looked in his dying words,[17] namely the
song of angels, the harmony, not of the spheres, but of the divine it-
self.

That power is already evident in an early poem which was in-
spired by two figures in a Dilherr illustration but which could not re-
main fixed to it.

DIE SEELE ERQUICKET SICH AN JESU

So spielen die lieblichen Buhlen Zusammen,
Und mehren im Spielen die himmlischen Flammen,
Das eine vermehret des anderen Lust
Und beiden ist nichts als die Liebe bewust.
Sie kämpfen im Lieben, sie geben sich eigen,

Die Vielheit mus endlich dem Einen hinweichen.
Er singet; sie spielet; er küsset, sie herzet;
Er lehret, sie höret; er lachet, sie scherzet.
Er saget: Wie bist du mir ewig erkoren!
Sie rufet: du bist mir zur Freude geboren!
Die beide verdoppeln das Echo in ein
Und schreien; mein Freund ist volkommentlich mein!
 Echo: Ich mein!
So recht, so vermehrt sich der göttliche Schein![18]

It is unfortunate that we still await a detailed study of the emblematic sources of Arnold's poetry. This is almost certainly because we still await a full index of emblem literature. For such an index to be of use to students of Arnold and many other Pietists and poets of his day, it must include indexes to as many books of meditation as possible. The emblems in Arndt's *Wahres Christenthum* should not unduly tax the indexer, and although the student of meditation may complain, the indexing of all editions after the initial one which included the emblems would not appear to be a useful exercise, particularly since many of the changes occur in nineteenth-century editions. The student of meditation interested in changes in a certain printing could easily check these against the facsimile edition included in an index in any event. The emblems and emblematic materials in Boehmist literature will prove somewhat more problematic. The person who indexes this material must be aware of textual borrowings in so far as they may affect the interpretation of emblematic material which appears without commentary; it is likely that in regard to this material the decision as to what will or will not be indexed will be made only after a closer study of the various types of literature is made. It is my opinion that all emblematic illustrations with explanations should be included in the index because of the significant influence of Boehmist ideas on major figures at a later period. The indexing of Boehmist material and Arndt frontispieces, even though not in the "classical" emblem form, will help to interpret other works and should therefore be included; it is otherwise with the Sudermann. An emblem index will help to interpret Sudermann, as it will to interpret Arnold, but in spite of the fact that Sudermann retains the emblem form in his poetic works, it is unlikely that the inclusion of those works in an index will be of any significant use to a student of spirituality or poetry other than to the student of Sudermann or of Arnold's *Poetische Lob- und Liebes-Sprüche.*

When one comes to the fringes, decisions as to what will be included and what will not be included in the index must almost certainly be made on the basis of possible future use: will or will not the in-

clusion of a work in the index help a significant number of students in
disciplines other than the obvious ones of Renaissance and Baroque lit-
eratures and art history? An overview of only a few books of meditation
within only one spiritual tradition (the proto-Pietist) indicates that
the inclusion of many of these books in such an index will be of use to
students of theology and religion in general and that it is signifi-
cant for studies on topics as late as the nineteenth and early twentieth
centuries. Indeed, an extensive meditative commentary on emblems, *Das
Herz des Menschen* by Johannes Gossner (1773-1858), is still in print,[19]
and although it is too late a work to be included in an emblem index,
the index would prove of use to the student of Gossner's spirituality,
its analogues and influences.[20]

NOTES

[1] Note for example their use in the study of poetry in Louis L. Martz, *The Poetry of Meditation* (New Haven, Conn., 1954). See as well Barbara K. Lewalski, *Donne's Anniversaries and the Poetry of Praise* (Princeton, N.J., 1973).

[2] Paul Althaus d.A., *Forschungen zur Evangelischen Gebetsliteratur* (Gütersloh, 1927).

[3] On the printing history and details on translations see my introduction to Johann Arndt, *True Christianity* (New York, 1979). The earliest edition of the *Vier Bücher von Wahrem Christenthum* was printed in Braunschweig by Andreas Duncker in 1606. The prayerbook *Paradiesgärtlein voller Christlichen Tugenden* appeared first in 1612 and was regularly reprinted with later editions of the *Wahres Christenthum* including the two printings from which the illustrations for this paper are taken: the Philadelphia Franklin printing of 1751 and the Philadelphia Kohler edition of 1856.

[4] Unfortunately the study of Elke Müller-Mees, *Die Rolle der Emblematik im Erbauungsbuch aufgezeigt an Johann Arndts 4 Büchern vom Wahren Christenthum* (Düsseldorf, 1974) did not arrive in time to be considered within this study.

[5] See above n. 3.

[6] Jacob Boehme, *The Way to Christ*, translated with introduction by Peter C. Erb (New York, 1978), pp. 1-3.

[7] See *Jacob Böhme: Sämtliche Schriften*, hrsg. Will-Erich Peuckert (Stuttgart, 1957), IV, ix for text of *Der Weg zu Christo*.

[8] For a brief introduction to Sudermann and a full bibliography see my "Medieval Spirituality and the Development of Protestant Sectarianism: A Seventeenth Century Case Study," *Mennonite Quarterly Review*, 51 (1977), 31-40.

[9] *Centuria similatudinum omnium doctrinarum*... (Strasbourg, 1624); exemplar: Schwenkfelder Library, Pennsburg, Pennsylvania.

[10] *Schöne ausserlesene Figuren vnd hohe Lehren. . . durch D.S. ...* [Strassburg, n.d.]; exemplar: Schwenkfelder Library, Pennsburg, Pennsylvania. *Hohe geistreiche Lehren vnd Erklärungen* ... (n.p., 1622); exemplar: Schwenkfelder Library, Pennsburg, Pennsylvania.

[11] For a full biography and bibliography of Arnold see my *The Role of Late Medieval Spirituality in the Work of Gottfried Arnold (1666-1714)*, (unpubl. Ph.D., Toronto, 1976).

[12] *Poetische Lob- und Liebes-Sprüche* printed with Arnold's *Geheimniss der Göttlichen Sophia* (Leipzig, 1700).

[13]Arnold's *Göttliche Liebes-Funcken* was printed in 1698 and reprinted at Frankfurt am Main by Johann David Zunner in 1701. The 1701 edition has been available to me for this paper.

[14]See Gottfried Arnold, *Neue göttliche Liebes-Funcken* printed with *Geheimniss*, 243.

[15]See *ibid.*, 245.

[16]*De Locutione angelorum* (Wittenberg, 1686).

[17]See Franz Dibelius, *Gottfried Arnold* (Berlin, 1873), 188.

[18]*Göttliche Liebes-Funcken*, I, 50-52.

[19]Lahr-Dinglingen (Baden): C. Schweickhart, O.J.

[20]Another area of study for which an emblem index will prove an important tool is Pennsylvania-German Fraktur Art. This artistic form practised in German-speaking areas of the United States from the late eighteenth to the early nineteenth century and in Ontario throughout the nineteenth century has been much neglected. Recent publications which reprint examples of Fraktur will make any future study of this artistic form including possible emblem sources much simpler. See Frederick S. Weiser and Howell J. Heaney, compilers, *The Pennsylvania-German Fraktur of the Free Library of Philadelphia*, 2 vols. (Breinigsville, Pa., 1976), and Michael Bird, *Ontario Fraktur* (Toronto, 1977).

A REVISED FORMAT FOR THE INDEX EMBLEMATICUS

Peter M. Daly

On the last day of the symposium discussion returned to the IE
and the various practical implications. There was unanimity on the need
for such an Index, the purpose of which would be to make accessible the
vast and diffuse information, both visual and verbal, contained in em-
blem books. There was also agreement on the general principles I had
outlined. However, certain modifications were suggested, some index
functions were redefined and alternative procedures recommended, which
will be briefly described in the following pages. In these discussions
Bezalel Narkiss, one of the editors of the *Index of Jewish Art*, played
an important role. The IE, as now conceived in organizational terms,
owes much to his experience. I should perhaps stress the theoretical
nature of the present conception, which must be tested and refined.

Originally I had foreseen the need for two sets of cards, or
two index files, one for motif (largely deriving from the *pictura*), the
other for meaning (deriving from the analysis of pictorial motif and
supported by quoted key words from the text). Somewhere a reproduction
of the emblem would have to appear, either on the motif card, or, as is
more likely, in a separate Emblem File. A listing of mottoes was also
considered useful. The new scheme represents a simplification to the
extent that it calls for one *descriptive master card* for each emblem
containing all the relevant analytical and descriptive information. This
single information card could be accompanied by a reproduction of the
emblem in question either in facsimile form or microfiche,[1] or by ref-
erence to an existing, available edition. In any case the IE must di-
rect the reader to an available reproduction, or provide one.

It was decided to explore further the possibility of analyzing
the complete emblem and any accompanying commentary or other elucidation
provided by the original emblem writer under seven headings: subject,
motto, picture, epigram, commentary, quotations, sources. Information
arranged under these headings could provide the data for the various in-
dexes that are required.

Before briefly characterizing these seven categories, I should
observe that there was widespread support for extending what might be
termed the translation service of the IE, by translating the motto com-

pletely and providing a brief resumé in English of the other textual
parts using close English equivalents for the original key words which
will also be quoted in the original language.

The emblem SUBJECT is essentially the emblem concept, i.e.,
meaning of the emblem as a whole, the theme or subject expressed through
text and picture. The subject more or less approximates to the Henkel/
Schöne identification of "Bedeutung" as indexed in their "Bedeutungs-
register." The intention here is also basically to use nouns, followed
by whatever modifiers are necessary, e.g., "love," "love, pain of,"
"love, unrequited." Thus, for instance, the SUBJECT of Alciatus's em-
blem 15 (Paris, 1542) discussed earlier[2] could read "*poverty hinders
*genius." An index of subjects could be produced automatically by the
computer which would be fairly well differentiated.

Under the heading MOTTO we envisage quoting the motto itself,
giving an asterisk to each key word which is to appear in the Index, and
offering a translation, the key terms of which would likewise be aster-
isked. Thus through the asterisked key word "love" the user is referred
to emblems in which the motto contains such key terms as "amor," "amour,"
"Liebe," and "love." For the German text of Alciatus's emblem 15 one
would quote "*Armuet verhindert manchen *kluegen *verstand, das er nit
*furkumbt," followed by an English translation "*poverty prevents many a
*clever *mind from *progressing."

Under the heading PICTURE a brief description of the semanti-
cally significant motifs contained in the *pictura* will be provided;
again with asterisked key words.

A brief summary of the EPIGRAM will be provided in English with
the key words asterisked. In this way both the representational and
interpretational functions of the epigram will be made accessible to the
Index user. However, in order to avoid unnecessary duplication in the
IE only those terms will be indexed which have not been identified
either in the *pictura* or motto. In order to preserve the linguistic
character of the original emblem book those key words asterisked in the
English paraphrase will also appear in the original language either as a
separate list, or embedded in the English text. Thus the user will be
referred to Alciatus's (Paris, 1542) emblem 15 through entries in the IE
under "poverty," "paupertas," and "Armut."

Since the emblem writer often appends a COMMENTARY to his em-
blem, which may replace or complement the epigram, the commentary must
also be considered an integral part of the emblem. Here rather than add
an English summary, it would probably suffice to list key words with

asterisks that should appear in the IE. Again only those terms which **have** not thus far been indexed under motto, picture, epigram should be **asterisked,** so as to keep all entries to a useful minimum.

Frequently the emblem writer will print QUOTATIONS which do not function either as motto or as epigram or as commentary, but are simply additional or ancillary material. If these were to be included in the IE, it would suffice to list and asterisk the key terms, accompanied by English translations.

On occasion the emblem writer identifies the SOURCE of his motto, quotation, or even a reference in an epigram. If a list of sources were to be included in the IE, it should be limited to those actually named by the emblem writer. It would be necessary to standardize all quotations; thus a Bible quotation from Galatians might be identified as B Gal I 7.

As an example of the kind of information that the revised IE would provide, we could return to Alciatus's emblem 15 on the relation of poverty to genius. The card for the Latin text would read as follows:

subject	author		short title				page/no
* poverty hinders * genius	Alciatus		Emblematum libellus				15
	date	place	language	ill.no	card no	code	
	1542	Paris	Lat				

motto	epigram
* paupertatem summis * ingenijs obesse ne * prouhantur * poverty hinders the greatest * genius so that it does not *advance	my right hand (*dextra) holds a stone (* lapidem), my left (*manus + *altera) wings (* alas) and *feathers (* pluma). My genius (ingenijs) would have taken me to the heavens, were it not for poverty (paupertas).
picture	
* genius, whose * right * hand is weighted down by a *stone, points with his * winged * left * hand towards the sky, where in a cloud appears a * prelate? or * prince?	commentary
quotation	source

Polyglot editions of emblem books are a particularly fascinating phenomenon. They raise many questions concerning the intentions of

author or publisher, and the target audiences for the different lan-
guages. The translations of the primary texts, usually Latin, range
from close literalism to extremely flexible recreation. In the case of
Otto van Veen's *Amorum emblemata* (Antwerp, 1608), where the Latin mot-
toes and epigrams are accompanied by Italian, French, and Spanish trans-
lations, these vernacular texts differ often considerably not only from
the original Latin, but also among themselves. For the IE polyglot
editions present special problems of organization. One way to overcome
some of the difficulties would be to use a separate information card for
each of the languages used in the edition. Thus, in the case of
Wolfgang Hunger's Latin-German edition of Alciatus emblems (Paris, 1542)
a second card for the German text would follow that for the Latin.

subject	*author*		*short title*				*page/no*
	Alciatus			Emblematum libellus			15
poverty hinders genius	*date*	*place*	*language*	*ill.no*	*card no*	*code*	
	1542	Paris	Ger				
motto			*epigram*				
*Armuet verhindert manchen *kluegen *verstand, das er nit *furkumbt poverty prevents many *clever *minds from *progressing			my right hand (*rechte *hand) is burdened by a stone (*stayn), my left (*linke) raised by ring of feathers (*feder ring). Many are born to the *arts (*kunst) but poverty (arm) makes all in vain.				
picture genius, whose right hand is weighted down by a stone, points with his winged left hand towards the sky, where in a cloud appears a prelate? or prince?							
			commentary				
quotation			*source*				

Similarly van Veen's polyglot love emblems would require sepa-
rate cards for the Latin and vernacular translations. This separation
of languages would keep the information more manageable and facilitate
easier access. Since some of the information on these cards would
remain the same, there would be no need to repeat the descriptions
given, for instance under SUBJECT and PICTURE. The different mottoes
and epigrams would require complete analysis, but only those key words
that are encountered for the first time need to be indexed, and there-

fore provided with an asterisk. Van Veen's emblem 70 on the need for
"silence in love" will illustrate the procedure.

subject	author	short title	page/no
*silence in *love	van Veen	Amorvm emblemata	70

	date	place	language	ill.no	card no	code
	1608	Antwerp	Lat			

motto	epigram
*Nocet esse *locutum *loquaciousness is *harmful	Eros (*Amor), finger (*digitis) to lips (*labra), and *Venus (*Cytherea) commands silence in love.

picture	
*Eros proper holds a *branch bearing *peach leaves and *peach fruit in his right hand; he puts the index *finger of his left hand to his *lips. to the side stands a *goose with a *stone in its beak	commentary

quotation	source
	Ovid [Ars amatoria II. 607 f.]

subject	author	short title	page/no
silence in love	van Veen	Amorvm emblemata	70

	date	place	language	ill.no	card no	code
	1608	Antwerp	Fr			

motto	epigram
*loyal & *secret	the *peach (*pesche) and *bird (*oisou) signify silence in love (*Amour). Chattering produces *troubles (*ennuis) and *envy (*envie).

picture	
	commentary

quotation	source

subject	author		short title				page/no
silence in love	van Veen		Amorvm Emblemata				70
	date	place	language	ill.no	card no	code	
	1608	Antwerp	Italian				

motto

*leale, e *secreto

*loyal and *secret

picture

epigram

silence of love (*Amor); the loud
*voice (*voce) produces envy
(*invidia)

commentary

quotation

source

subject	author		short title				page/no
silence in love	van Veen		Amorvm emblemata				70
	date	place	language	ill.no	card no	code	
	1608	Antwerp	Span				

motto

El *amor *puro y *perfecto
ha de ser *fiel y secreto
Love *pure and *perfect
should be *faithful and secret

picture

epigram

Love, finger (*dedo) to lips (*labos),
commands silence (*silencio) with
*reverence (*reverencia), prudence
(*aviso) and *fear (*miedo). Venus
has her *mystery (*mysterio); the
*envious (*invidiose) does not dis-
turb the *silent (*callado).

commentary

quotation

source

The indexing of English texts raises a new, if minor, problem. Since English is the basic language of description and analysis in the IE, an ambiguity can never arise when quoting non-English words in the descriptive cards and in the indexes. It will always be clear that "Armut" and "paupertas" are quotations from the original texts, even though they do not appear within quotation marks. However, when English emblem books are indexed a potential ambiguity does arise, which could be resolved by underlining the English quotation, thereby setting it off from the language of the Index.

Probably the only efficient way to render accessible the information provided by the descriptive master cards is to produce a series of computer-generated indexes. Enlisting the aid of the computer for the preparation of indexes brings with it, however, new problems, the solutions to which may influence the form of the IE. Since the computer can only sort and list the material in the form in which it receives it, and since the computer cannot of itself recognize the basic forms of inflected words, the problems of lemmatization and homography will require close attention, as I indicated earlier.[3]

It is evident that as far as the production of an IE is concerned many questions still have to be considered. They fall under several headings. Firstly, the materials must be limited. Just how much information from each emblem can be made accessible to the user of the IE? The problem of the sheer mass of emblem books must be faced. Whether they could all be indexed, and in which order, remains to be discussed. Various arguments could be advanced for proceeding historically, i.e., taking the production of, say, the first fifty years; or concentrating on books in a certain language or languages--for example, English emblem books constitute a small but complete collection in themselves; or again a selection according to subject matter--moral, political, religious, and so on--would make some sense.

The actual form that a "publisher" IE might take could only be determined after discussion with publishers. However, one principle seems clear to me: if the computer is to be utilized then as much data as possible should be sorted and indexed, even though some of it, indeed, most of it, may never be incorporated directly into the IE and thus find its way into the libraries of the world. However, both computer technology and to a lesser extent publishing methods are progressing and changing at such a rate that presently undreamed of modes of dissemination may make the IE, as an information system, completely accessible in the future.

NOTES

[1]Inter Documentation AG (Zug, Switzerland) has made available on microfiche some 290 emblem books based on the Praz bibliography. The Company plans to expand this by adding from the large collection at the Herzog August Bibliothek in Wolfenbüttel, Germany.

[2]Cf. Daly, pp. 44-48 above.

[3]Cf. Daly, p. 49 above.

BIBLIOGRAPHY OF EMBLEM BOOKS CITED

Alciatus, Andreas. *Emblematum liber.* Augsburg, 1531 [Henkel/Schöne]; reprinted, Olms, 1977.

_____. *Emblematum libellus.* Paris, 1542 [Henkel/Schöne]; reprinted, Wissenschaftliche Buchgesellschaft, 1967.

Aneau, Barthélemy. *Picta Poesis.* Lyon, 1552 [Henkel/Schöne].

Anonymous. *Thronus Cupidinis.* No. pl., 1620; reprinted, University Library, Amsterdam, 1968.

_____. *Typus Mundi.* Antwerp, 1627.

_____. *Imago Primi Saeculi.* Munich, 1640.

Ayres, Philip. *Emblemata amatoria.* London, 1683; reprinted, Scolar Press, 1969.

Borja, Juan de. *Empresas Morales.* Prague, 1581 [Henkel/Schöne].

Bovio, Carlo, *Ignatius Insignium.* Rome, 1655.

Bruck, Jacob von. *Emblemata moralia et bellica.* Strasbourg, 1615 [Henkel/Schöne].

Camerarius, Joachim. *Symbolorvm et emblematvm ex volantibvs et insectis.* Nuremberg, 1596 [Henkel/Schöne].

Cats, Jacob. *Silenus Alcibiadis, sive Proteus.* Middelburg, 1618.

_____. *Emblemata moralia et aeconomica.* Rotterdam, 1627. [Henkel/Schöne].

Corrozet, Gilles. *Hecatomgraphie.* Paris, 1540 [Henkel/Schöne].

Covarrubias Orozoco, Sebastian de. *Emblemas Morales.* Madrid, 1610 [Henkel/Schöne].

Custos, Raphael. *Emblemata amoris.* Augsburg, 1622 [Henkel/Schöne].

Drexel, Jeremias. *Orbis Phaëton.* Munich, 1629.

Engelgrave, Heinrich. *Lux Evangelica.* Antwerp, 1648.

Fraunce, Abraham. *Insignium, Armorum, Emblematum, Hieroglyphicorum, et Symbolorum.* London, 1588.

Friedrich, Andreas. *Emblemata nova, das ist New Bilderbuch.* Frankfurt, 1617.

Hayneufve, Julian. *Scala Salutis.* Cologne, 1650.

[Heinsius, Daniel]. *Quaeris quid sit amor?* N. pl., 1601.

Heinsius, Daniel. *Nederduytsche Poemata*. Amsterdam, 1616; reprinted, Lang, 1979.

_____. *Emblemata amatoria*. N. pl. [Amsterdam?], n. d. [1607?]; reprinted, Scolar Press, 1973.

_____. *Het ambacht van Cupido*. Leiden, 1615 [Henkel/Schöne].

Hesius, Willem. *Emblemata sacra*. Antwerp, 1636.

Hooft, Pieter Corneliszoon. *Emblemata amatoria*. Amsterdam, 1611 [Henkel/Schöne]; reprinted, University Press Amsterdam, 1972.

Hugo, Hermann. *Pia Desideria*. Antwerp, 1624; Bk. III reprinted, Olms, 1971.

Krul, Ian Hermansz. *Minne-Spiegel ter Deughden*. Amsterdam, 1639.

Meisner, Daniel. *Politisches Schatzkästlein*. Frankfurt, 1628; bk. I, pt. 1 reprinted, Hofmann, 1962.

Montenay, Georgette de. *Emblemes, ou Devises Chrestiennes*. Lyon, 1571 [Henkel/Schöne].

Paradin, Claude. *The Heroicall Devises of M. Claudius Paradin*. Translated by P. S. London, 1691; reprinted, Scolar Press, 1971.

Peacham, Henry. *Minerva Britanna*. London, 1612; reprinted, Scolar Press, 1969.

_____. *Emblemata varia*. Ms, ca. 1621; published by Scolar Press, 1976.

Perrière, Guillaume de la. *Le Theatre des bons engins*. Paris, 1539 [Henkel/Schöne]; reprinted, Scolar Press, 1973.

Quarles, Francis. *Emblemes*. London, 1635.

_____. *Hieroglyphikes of the Life of Man*. London, 1638; reprinted, Scolar Press, 1975.

Ripa, Cesare, *Iconologia*. Rome, 1603; Hertel ed. reprinted, Dover, 1971.

Rollenhagen, Gabriel. *Selectorum emblematum centuria secunda*. Arnheim, 1613 [Henkel/Schöne].

_____. *Nvclevs emblematvm selectissimorvm*. Arnheim, 1611 [Henkel/Schöne].

Saavedra Fajardo, Diego de. *Idea de un Principe Politico Christiano*. Amsterdam, 1659 [Henkel/Schöne].

Simeoni, Gabriel. *Metamorphose d'Ovide figurée*. Lyon, 1557.

Stam, W. I. *Cupido's Lusthof*. Amsterdam [1613].

Stengel, Georg. *Ova Paschalia*. Munich, 1634.

Sudermann, Daniel. *Centuria similitudinum*. Frankfurt, 1624.

_____. *Schöne auserlesene Figuren*. Frankfurt, 1623.

Suquet, Antoine. *Via viae aeternae*. Antwerp, 1620.

Taurellus, Nicolaus. *Emblemata Physico-Ethica*. Nuremberg, 1595 [Henkel/Schöne].

van der Not. *A Theatre for Worldlings*. London, 1569.

van Veen, Otto. *Q. Horati Flacci Emblemata*. Antwerp, 1607; reprinted, Olms, 1972.

_____. *Amorum Emblemata*. Antwerp, 1608 [Henkel/Schone]; reprinted, Olms, 1970.

_____. *Amoris Divini Emblemata*. Antwerp, 1615.

Whitney, Geoffrey. *A Choice of Emblemes*. Leyden, 1586; Henry Green ed. reprinted, Blom, 1967.

Willet, Andrew. *Sacrorum Emblematum Centuria Una*. N. pl., [1592?].

Wither, George. *A Collection of Emblemes*. London, 1635; reprinted, Scolar Press, 1973.

BIBLIOGRAPHY OF WORKS DEALING WITH THE EMBLEMATIC TRADITION

Breugelmans, Ronald. *"Quaeris quid sit amor?* Ascription, Date of Publication and Printer of the Earliest Emblem Book to be Written and Published in Dutch." *Quaerendo,* 3 (1973), 281-90.

Clements, Robert J. *Picta Poesis: Literary and Humanistic Theory in Renaissance Emblem Books.* Rome, 1960.

Daly, Peter M. "The Poetic Emblem." *Neophilologus,* 65 (1970), 381-97.

_____. "Emblematic Poetry of Occasional Meditation." *German Life and Letters,* 25 (1972), 126-39.

_____. *Dichtung und Emblematik bei Catharina Regina von Greiffenberg.* Bonn, 1976.

_____. "Of Macbeth, Martlets and other 'Fowles of Heauen'." *Mosaic,* 12 (1978), 23-46.

_____. *Literature in the Light of the Emblem.* Toronto, 1979.

_____. *Emblem Theory: Recent German Contributions to the Characterization of the Emblem Genre.* Nendeln, 1979.

Dieckmann, Lieselotte. "Renaissance Hieroglyphics." *Comparative Literature,* 9 (1957), 308-321.

_____. *Hieroglyphics: The History of a Literary Symbol.* St. Louis, Miss., 1970.

Dimler, G. Richard, S. J. "A Bibliographical Survey of Jesuit Emblem Authors in German-Speaking Territories: Topography and Themes." *Archivum Historicum Societatis Jesu,* 45 (1976), 129-38.

_____. "Jesuit Emblem Books in the Belgian Provinces of the Society (1587-1710): Topography and Themes." *Archivum Historicum Societatis Jesu,* 46 (1977), 377-87.

_____. "A Bibliographical Survey of Jesuit Emblem Authors in French Provinces 1618-1726: Topography and Themes." *Archivum Historicum Societatis Jesu,* 47 (1978), 240-50.

Freeman, Rosemary. *English Emblem Books.* London, 1948; reprinted 1967.

Giehlow, Karl. *Die Hieroglyphenkunde des Humanismus in der Allegorie der Renaissance, besonders der Ehrenpforte Kaisers Maximilian I: Jahrbuch der Kunsthistorischen Sammlungen des allerhöchsten Kaiserhauses,* XXXII, Heft 1. Vienna/Leipzig, 1915.

Green, Henry. *Shakespeare and the Emblem Writers.* London, 1870.

Harms, Wolfgang. *"Mundus imago Dei est.* Zum Entstehungsprozess zweier Emblembücher Jean Jacques Boissards." *Deutsche Vierteljahrs-*

schrift für Literaturwissenschaft und Geistesgeschichte, 47 (1973), 223-44.

_____. "Der Fragmentcharakter emblematischer Auslegungen und die Rolle des Lesers. Gabriel Rollenhagens Epigramme." *Deutsche Barocklyrik. Gedichtinterpretationen von Spee bis Haller.* Ed. Martin Bircher and Alois M. Haas. Bern and Munich, 1973; pp. 49-64.

Harms, Wolfgang and Freytag, Hartmut. *Ausserliterarische Wirkungen barocker Emblembücher: Emblematik in Ludwigsburg, Gaarz und Pommersfelden.* Munich, 1975.

Heckscher, William S. "Renaissance Emblems." *The Princeton University Library Chronicle,* 15 (1954), 55-68.

Heckscher, William S. and Wirth, Karl-August. "Emblem, Emblembuch." In *Reallexikon zur Deutschen Kunstgeschichte,* Vol. 5, Cols 85-228. Stuttgart, 1959.

Henkel, Arthur. "Die geheimnisvolle Welt der Embleme." *Heidelberger Jahrbücher,* 19 (1975), 1-23.

Henkel, Arthur and Schöne, Albrecht. *Emblemata. Handbuch zur Sinnbildkunst des XVI. und XVII. Jahrhunderts.* Stuttgart, 1967; ergänzte Neuausgabe, Stuttgart, 1976.

Höltgen, Karl Josef. *Francis Quarles (1592-1644). Meditativer Dichter, Emblematiker, Royalist: Eine biographische und kritische Studie.* Tübingen, 1978.

Homann, Holger. "Prolegomena zu einer Geschichte der Emblematik." *Colloquia Germanica,* 1, (1968), 244-57.

_____. *Studien zur Emblematik des 16. Jahrhunderts.* Utrecht, 1971.

Hueck, Monika. *Textstruktur und Gattungssystem: Studien zum Verhältnis von Emblem und Fabel im 16. und 17. Jahrhundert.* Kronberg/Ts, 1975.

Index of Christian Art, Princeton University. Princeton, N.J. Department of Art and Archaeology, 1963.

Index of Jewish Art. Ed. Bezalel Narkiss and G. Sed-Rajna. Paris and Jerusalem, 1976.

Jongh, E. de. *Zinne en minnebeelden in de schilderkunst van de zeventiende eeuw.* N. pl. [1967].

Jöns, Dietrich Walter. *Das "Sinnen-Bild." Studien zur allegorischen Bildlichkeit bei Andreas Gryphius.* Stuttgart, 1966.

_____. "Emblematisches bei Grimmelshausen." *Euphorion,* 62 (1969), 385-91.

_____. "Die emblematische Predigtweise Johann Sauberts." In *Rezeption und Produktion zwischen 1570 und 1730: Festschrift für Günther Weydt zum 65. Geburtstag,* pp. 137-58. Ed. Wolfdietrich Rasch, Hans Geulen, und Klaus Haberkamm. Bern and Munich, 1972, pp. 137-58.

Landwehr, John. *Dutch Emblem Books: A Bibliography*. Utrecht, 1962.

_____. *Emblem Books in the Low Countries 1554-1949: A Bibliography*. Utrecht, 1970.

_____. *German Emblem Books: A Bibliography*. Utrecht, 1972.

Lesky, Grete. *Barocke Embleme in Vorau und anderen Stiften Österreichs*. Graz, [1962].

Miedema, Hessel. "The Term *Emblema* in Alciati." *Journal of the Warburg and Courtauld Institutes*, 31 (1968), 234-50.

Monroy, Ernst Friedrich von. *Embleme und Emblembücher in den Niederlanden 1560-1630*. Utrecht, 1964.

Ohly, Friedrich. "Vom geistigen Sinn des Wortes im Mittelalter." *Zeitschrift für deutsches Altertum und deutsche Literatur*, 89 (1958/59), 1-23.

Penkert, Sibylle. "Zur Emblemforschung." *Gottingische Gelehrte Anzeigen*, 224 Jahrgang (1972), 100-120.

Porteman, K. *Inleiding tot de Nederlands emblemataliteratur*. Groningen, 1978.

Praz, Mario. *Studies in Seventeenth-Century Imagery*. 2nd. ed. Rome, 1964.

Schöne, Albrecht. *Emblematik und Drama im Zeitalter des Barock*. 2nd. ed. Munich, 1968.

_____, "Hohburgs Psalter-Embleme." *Deutsche Vierteljahrsschrift für Literaturwissenschaft und Geistesgeschichte*, 44 (1970), 655-69.

Stegemeier, Henri. "Problems in Emblem Literature." *Journal of English and Germanic Philology*, 45 (1946), 26-37.

Sulzer, Dieter. "Zu einer Geschichte der Emblemtheorien." *Euphorion*, 64 (1970), 23-50.

Thompson, E. N. S. *Literary By Paths of the Renaissance*. New Haven, 1924.

Tiemann, Barbara. "Sebastian Brant und das frühe Emblem in Frankreich." *Deutsche Vierteljahrsschrift für Literaturwissenschaft und Geistesgeschichte*, 47 (1973), 598-644.

Tung, Mason. "Whitney's A *Choice of Emblemes* Revisited: A Comparative Study of the Manuscript and the Printed Versions." *Studies in Bibliography*, 29 (1976), 32-101.

Verwey, Herman de la Fontaine. "The *Thronus Cupidinis*." *Quaerendo*, 8 (1978), 29-44.

_____. "Notes on the début of Daniel Heinsius as a Dutch Poet." *Quaerendo*, 3 (1973), 291-308.

Volkmann, Ludwig. *Bilderschriften der Renaissance, Hieroglyphik und Emblematik in ihren Beziehungen und Fortwirkungen.* Leipzig, 1923.

Vries, Anne Gerard Christian de. *De Nederlandsche emblemata. Geschiedenis en Bibliographie tot di 18ᵉ eeuw.* Amsterdam, 1899; reprinted, Utrecht, 1976.

Wittkower, Rudolf. "Hieroglyphics in the Early Renaissance." In *Developments in the Early Renaissance,* pp. 58–97. Ed. Bernard S. Levy. Albany, 1972.

Young, Alan R. "A Biographical Note on Henry Peacham." *Notes and Queries,* N.S., 24 (1977), 215.